Roadshow Anthropology

ROADSHOW

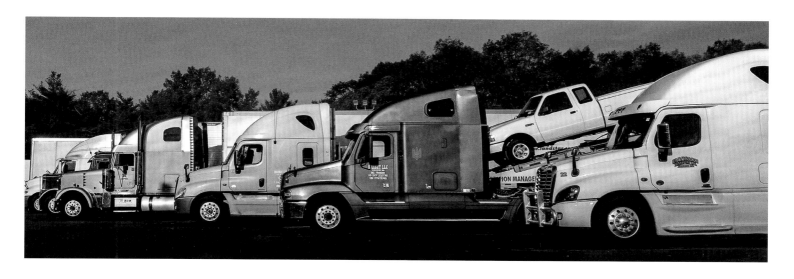

ANTHROPOLOGY

MARK CHESTER

Foreword by Pico Iyer

UMassAmherst | Libraries

Special thanks and affection to Kathleen for our "road less traveled" journeys. You are a fun traveler and a photographer with a good eye and tender heart.

Copyright © 2023 by Mark Chester
Published by UMass Amherst Libraries
All rights reserved
Printed in Canada
Distributed by Mill River Books, University of Massachusetts Amherst,
 Amherst MA 01003

ISBN 978-1-62534-740-4 (paper)

Conception and Photography: Mark Chester
Photographic Post Production: Ken Alexander
Book and Cover Design: Rebecca Neimark, Twenty-Six Letters

Library of Congress Cataloging-in-Publication Data
Names: Chester, Mark, author, photographer. | Iyer, Pico, writer of foreword.
Title: Roadshow anthropology / Mark Chester ; foreword by Pico Iyer.
Description: [Amherst] : UMassAmherst Libraries, [2023] | Summary: "This
 collection of engaging black-and-white photographs captures America
 from the driver's seat. Offering fresh perspectives on the United States'
 iconic highways, byways, back roads, and small-town main streets,
 Mark Chester puts America's unique spirit of innovation on full display.
 With humor and pathos, Roadshow Anthropology explores high and low
 culture and the worlds of commerce, architecture, design, advertising,
 and fashion. As a social commentator and a connoisseur of Americana,
 Chester pays homage to a range of influences, including the work of
 photojournalist Lee Friedlander"— Provided by publisher.
Identifiers: LCCN 2023013420 | ISBN 9781625347404 (paper)
Subjects: LCSH: United States—Description and travel. | Street
 photography—United States. | Landscape photography—United States.
Classification: LCC E169.Z83 .C47 2023 | DDC 778.9/40973—dc23/
 eng/20230419
LC record available at https://lccn.loc.gov/2023013420

British Library Cataloguing-in-Publication Data
A catalog record for this book is available from the British Library.

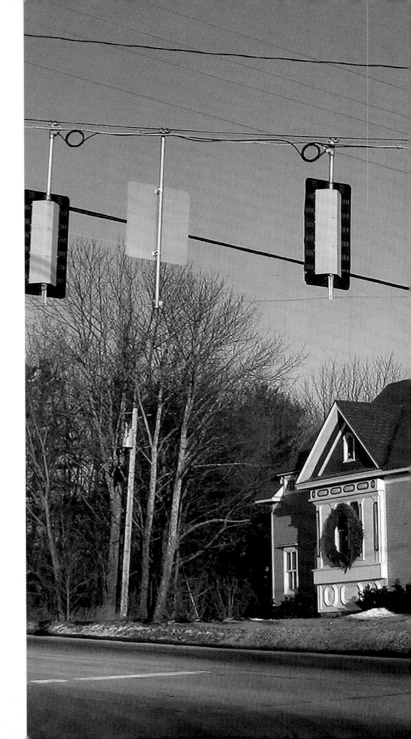

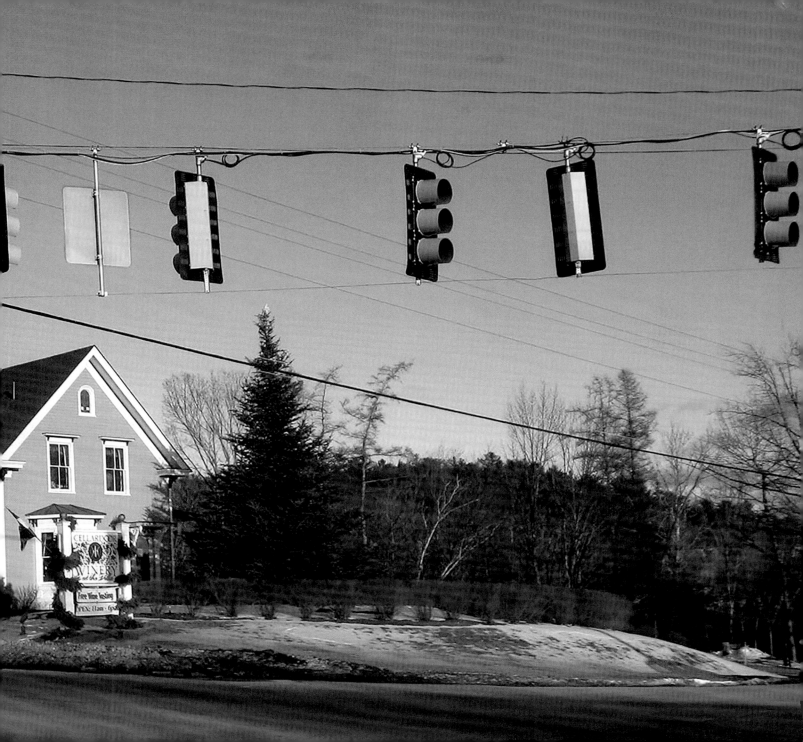

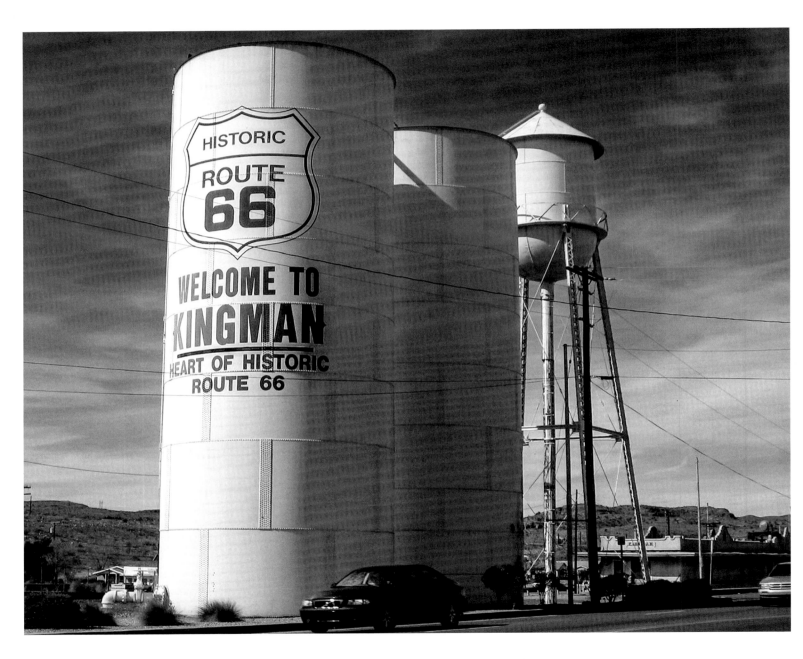

Signs and Wonders

Pico Iyer

The great open road of America: it's what I dreamed of as a boy, growing up in cramped and aging England. The streets around me were narrow and came to an end very soon; the signs above them were sober, practical. Stone walls all around and constant low grey skies conferred on us all an unvarying sense of imprisonment. How could I not dream—as I stepped into a classroom constructed in 1441 to sing the Lord's Prayer in Latin— of broad and liberating America, where all the world (sublime, ridiculous, and a promiscuous combination of them both) came together at every moment?

When our teachers weren't looking, my friends and I inhaled great gusts of Kerouac, his character Dean Moriarty speeding across America as if the highway itself were a foreign substance. We got by heart "Truckin'" and "Friend of the Devil" and every Merle Haggard or Willie Nelson song that offered a vision of movement, of new lives, of a road that never ended. When the novel *Another Roadside Attraction* arrived, some of us bought it for the name alone; we knew already that along the wide highways of the West, the sense of space unending, we could come across go-carts, majestic rock formations, geodesic domes, truck stops, "mystery spots," and billboards singing of the Good Life.

Our drug of choice in those days was a 30-day pass that the Greyhound bus company was offering for $99, promising unlimited travel across the land. "Born to Run" was in our ears, and the Beat novel *Go* was in our hands as we took in the unfolding tragic-comedy: neon-lit bars and wild elemental skies, churches in the wilderness, and the road-shack motels that Nabokov had turned into a kind of poetry, voices on the A.M. radio promising salvation, damnation, and almost everything else, for a price.

It's no surprise that, even now, if you travel along the back roads of the New World, or its Arizona highways, many of the visitors you'll meet come from the Old World, in search of youthfulness and space, some trace of future tense. Two of my friends here in Japan, who run a motorcycle-repair shop in the shade of Kyoto's eastern hills, got married in the city founded in the year 794 and then flew right over to Route 66 to hire big hogs, knowing little about that thoroughfare other than it was a talisman, a universal shorthand for adventure.

The beauty of the American road, we all can see, is that you never know what's coming next, and much of it

may be zany, uplifting, sad: a tow truck or a mom-and-pop camper pulling along some racing cars. Everything is on display, so you don't have to leave your seat to absorb every last tremor of the collective subconscious. America, when I was a kid, was famous for its drive-in movies, its drive-thru burger joints, even its drive-through funerals; for us, it was the natural home of drive-through sociology as well, since it paraded its longings so nakedly among the eighteen-wheelers and the clapboard churches.

All of this is exactly what I see—and savor—in Mark Chester's photography: the swinging traffic lights, the billboards that speak for an Ozzie-and-Harriet world, the relics of an industrial and whimsical America—

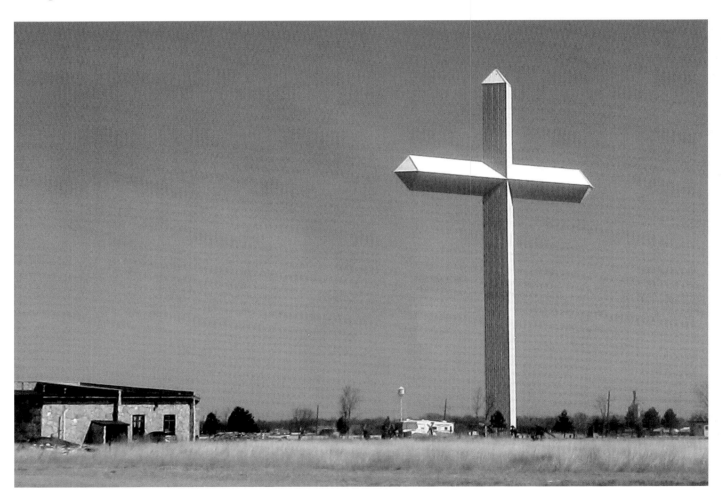

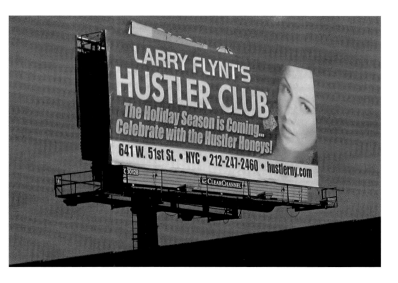

even Santa on a motorbike, who might have been waiting for my Japanese friends. Here is all the surprise and serendipity that comes to anyone driving across the nation, the spiritual home of car culture; you'll meet Mr. Cesspool and Mr. Rooter along the way and lose all track of whether people are taking their idiosyncrasies too seriously or their craziness too lightly.

The road, as it comes to us here in this mobile scrapbook, sings opf a bygone America that was unembarrassed about giant burgers and Hustler clubs; but it speaks also of an America that has never been shy of thinking about the future. Most of all, it celebrates a society always on the move, in which red state and blue state, inflatable duck, and admonishing cross are all thrown together, with majestic canyon and man-

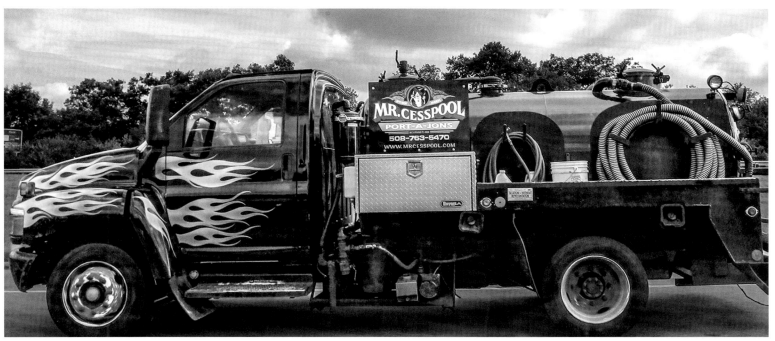

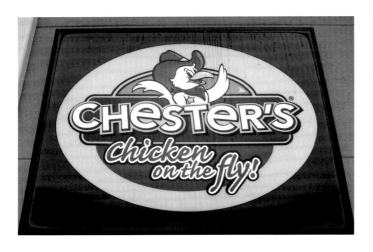

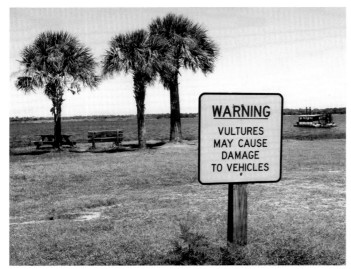

made folly thrown in. A constantly moving slideshow of unexpectedness.

It's no surprise that Mark Chester once produced a book with America's longtime, down-home laureate of the open road, Charles Kuralt. It feels as if he is driving for life along a freeway mapped at times by Robert Frank and even Walker Evans; collecting signs and wonders much as William Least Heat Moon did in his explorations of Blue Highways, or Reyner Banham, the English architectural critic who championed the outlandish diners of Los Angeles, the emancipation of the desert, and a vision of history as seen through a rear-view mirror.

The very season I came of age, at twenty-one, I made my own way over to California and drove all the way from Santa Barbara to Boston in barely sixty hours, the windows down, the signs around me announcing prophecies, the nonstop chatter of America coming at me as I raced along Interstate 40. Nine months later, I was heading back in the opposite direction, the slow way, through the South, hoping to play anthropologist with the theme-parks, the jukebox laments, the storied pilgrimage sites of Roadside America. Nashville and Graceland and Memorial Stadium in Baltimore, Zion and Santa Fe and (of course) Truth or Consequences.

Where else could you even hear the phrase "mobile home" and see people along the way who'd packed up their lives and were heading West, although they

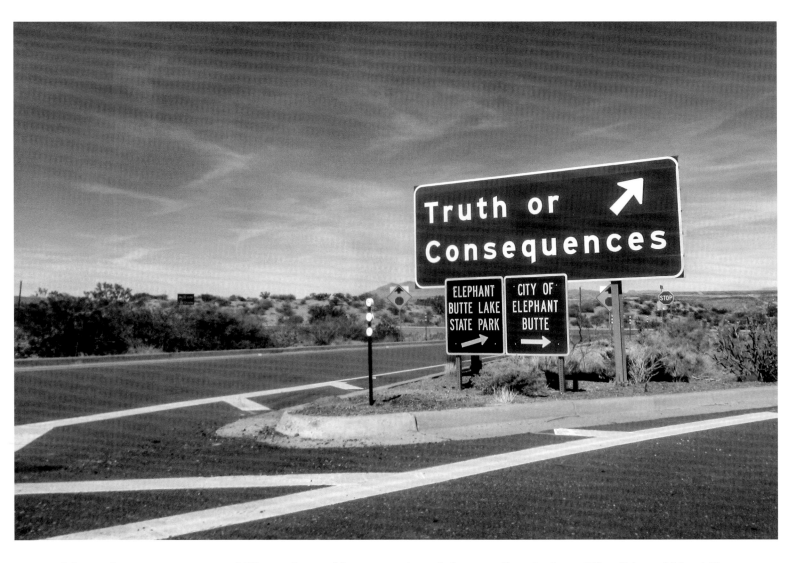

might not be so young anymore? Where else could you glimpse broken dreams and dreams restored amidst signs warning of vultures and telling you to brush your teeth? Australia has emptiness, but humans barely make an impression on its devouring spaces. Canada has grandeur, but its claims for it are modest. I've traveled across Patagonia and Namibia and Mongolia, but none of them offers the sweet and crazy innocence of Main Street, U.S.A. America is the land where people project their dreams in bold type against the heavens and remain convinced they can fashion something new tomorrow.

"Afoot and light-hearted I take to the open road," begins the poem by Whitman that could be the nation's unofficial national anthem. "Healthy, free, the world before me, / The long brown path before me leading wherever I choose." The fact of the matter is that you can't find the same sensation on the Autobahn, or the Meishin Expressway not far from where I write this in Japan.

Nowhere I've been offering such a Whitman's sampler of oddities and national parks and gimcrack sideshows. The open road is all but an emblem of democracy, since the passing lane is open to anyone and the trailer park, even the motor home, within the budget of many. One of the curiosities—maybe the beauties—of the late twentieth century is that the strongest nation in the world was among the youngest, which meant that the horizon never receded and anything went almost everywhere.

Battered Nissan could ride side-by-side with super-model Tesla across the highways of the land, taking in the same landscape of garden furniture or (very) low-flying planes. What made America great is here,

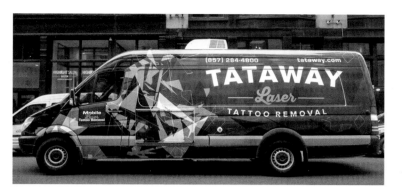

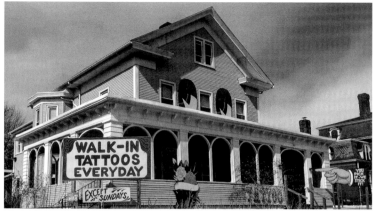

and what made America endearingly silly. The fierce battlements of farmland and the sudden skyscrapers of cities. As you drive through the Far West, hours of nothingness give way abruptly to a spaghetti junction of overpasses and freeways—around Phoenix, say—and then you're back in a realm of carnival attractions, unidentified flying objects, dinosaurs, and a sign telling you to watch for bears.

It's become fashionable to try to project one America over another, a black land or a white land, the home of churches or of rebels; for those of us from elsewhere, the glory of America lies in its undifferentiated variety and abundance, the way it's a compendium of other lands, where you'll find stuffed bears in a passenger seat and funerals peddled like doughnuts.

One thing that comes powerfully home to me in this work is how the man-made plays off the blessings conferred on us by Nature. Mr. Chester has a droll and mischievous eye for our flimsiest hopes, our follies, the new car in front of a car-hood mounted like a moose-head trophy; his is the fondness, it seems to me, of an uncle who can't help being amused at how, unregenerate as ever, we keep trying to do better, or longing for more.

The American he gives us is a land of aspiration, a land of knockabout humor, and the distance between them both. Chester's chicken on the fly, in a sense.

Most of all, it's a vision that belongs to all of us, every one of the millions driving the highways and backstreets, forming our own vision of how to put dream and reality together. Much as the songs of Springsteen alternately urges us to break out of factory towns and our father's dead-end lives and take to the open highway, and then—in darker, lonely solo albums—remind us of the confusion and drift that sometimes results.

The tattoo-removal van sits next to the walk-in tattoo parlor. Smashed cars are found right next to the warning about road accidents. Signs promise new lives, while others find their future in old cars. There's wonder here and release and comedy and weirdness, and the best thing of all is how one turns into the other and then back again. If someone were to ask me why I keep coming back to America, over and over, I'd say, "Open this book and get ready to laugh—and to marvel."

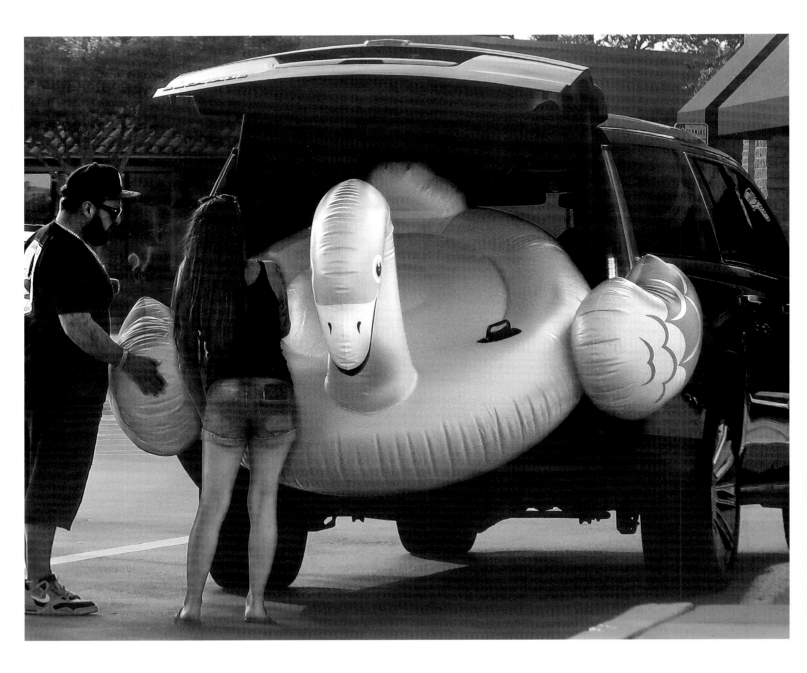

Photographer's Notes

Mark Chester

Driving cross-country on interstate highways, back roads, gravel roads, and small-town Main Streets, I observed a picture of a quirky America emerging in New England, parts of the south and southwest, the midwest and Pacific coast states.

I am basically a street photographer. But for this project, from 2010 to 2022, I morphed into an "auto-seer" taking photographs from my Subaru stopped in traffic or parked in malls and on streets. I shot directly through the front windshield or side windows,

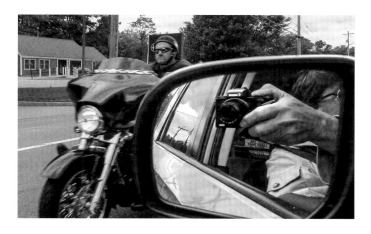

capturing store signs, architecture, billboards, trucks hauling weird-looking equipment, commercial vans advertising their wares, and people in their own car.

This is a story book, not an art book. I've thoughtfully composed and paired images on facing pages that relate to various subjects—health, transportation, religion, design, art, humor, innovation, advertising, nature, science, among other categories that you the viewer can interpret.

Newsman Charles Kuralt, whose book *Dateline America* I photographed in 1978, is a pivotal role model in my photojournalistic pursuits. With this book, I also pay homage to photographer Lee Friedlander for his *America by Car* series of the 1990s.

I used various models of the Canon PowerShot point-and-shoot digital camera series—the Canon SD850 IS, PowerShot S90, PowerShot G7X, and the PowerShot G7X Mark II—to record these roadshow sightings.

The PowerShot is easy to hold in one hand. I can just point and shoot at the subject, never having to look at the camera's screen. But it took practice to aim the lens and simultaneously get the picture, driving at sixty miles per hour. At all times, I literally was focused

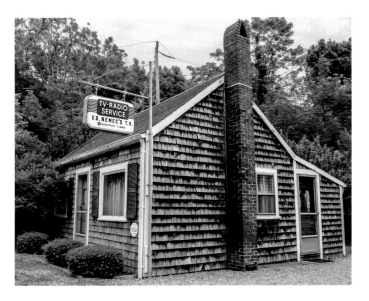

on the road while holding up the camera and clicking the shutter at the "decisive moment." It was educated guessing at first, but I became better at coordinating the metrics of car speed, clicking the shutter, and aiming the lens while keeping my eyes on the road and surrounding traffic, like a sharpshooter calculating wind velocity with other factors. Often, I was lucky to get the subject in sharp focus without blurring it.

For example, when I saw a billboard ahead, I slowed down approaching it, then depressed the shutter button to engage the auto-focus mode first, then clicked several frames quickly. I obeyed the speed limits, and stayed far from other vehicles, generally on the right-hand side of interstate roads.

With trucks hauling strange-looking machinery, vans with eye-catching graphics or drawings and too

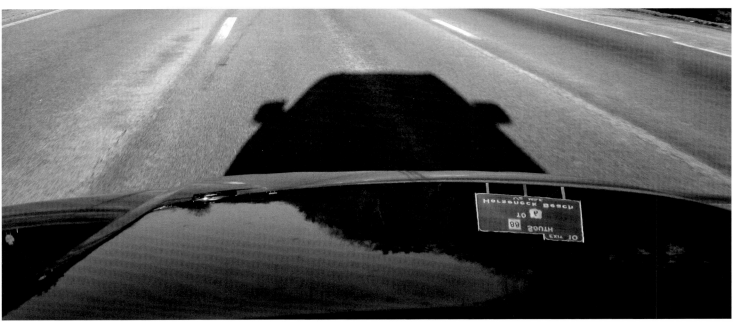

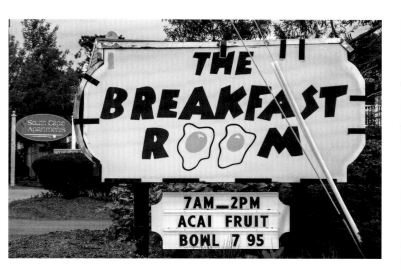

cute names, I generally drove on the left side slightly behind, aiming the camera to catch an elongated side view. Sometimes I included an element of the car—doorframe, window, side mirror, or the front hood—into the image. I noticed people's clothing, gestures, and interactions with others when stopped at a red light.

During the Covid-19 pandemic, I saw relevant signs—"Get Vaccinated" and "No Mask, No Service." Signs of solidarity supporting Ukraine and social justice were everywhere.

Driving from Massachusetts for an exhibition in Tucson in 2014, I dodged snowstorms in the Texas panhandle. Cottonwood trees laden with iced branches stood tall in a low fog, creating an alien landscape. State border signs offered mystery: *Welcome to New Mexico, Land of Enchantment.*

Travel by auto is all about taking the road less traveled and taking the road *well*-traveled. And whichever direction I took, there was always a breakfast place.

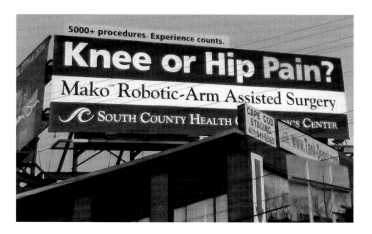

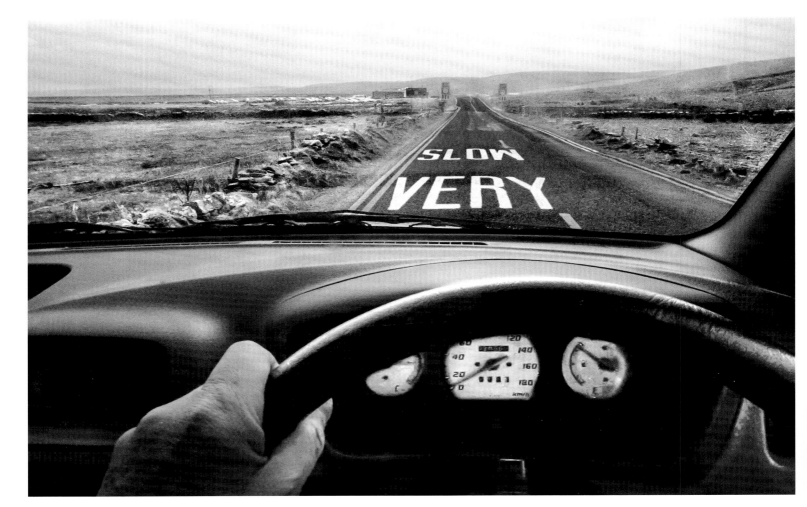

Roadshow Anthropology

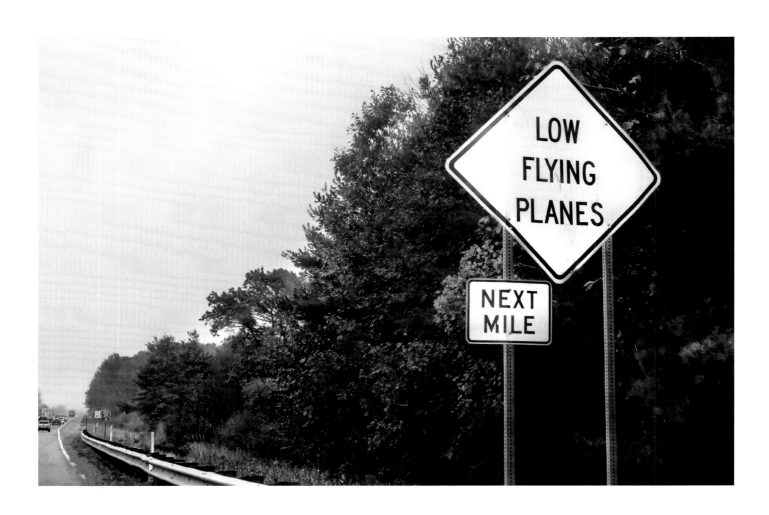

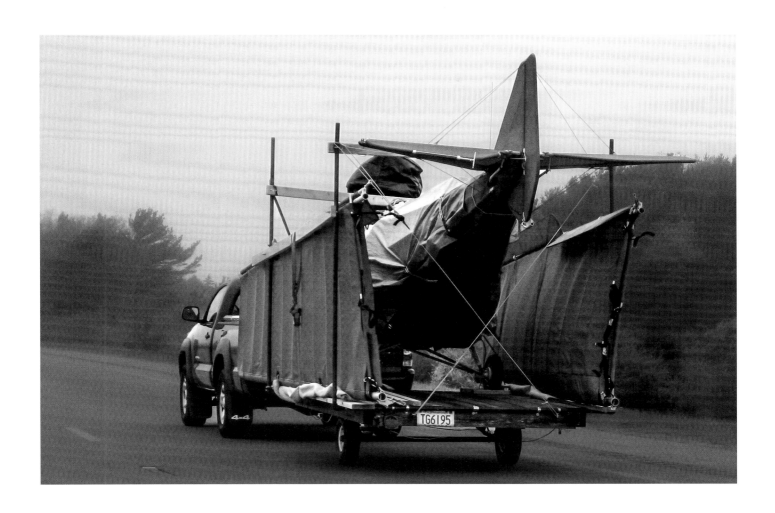

AIRCRAFT
OPERATING
AREA
ENTER ONLY WITH
AIRPORT MANAGER'S
PERMISSION

COMMONWEALTH OF MASSACHUSETTS
AERONAUTICS COMMISSION
AERONAUTICS REGULATIONS 702 CMR 5023
MASSACHUSETTS AERONAUTICS COMMISSION

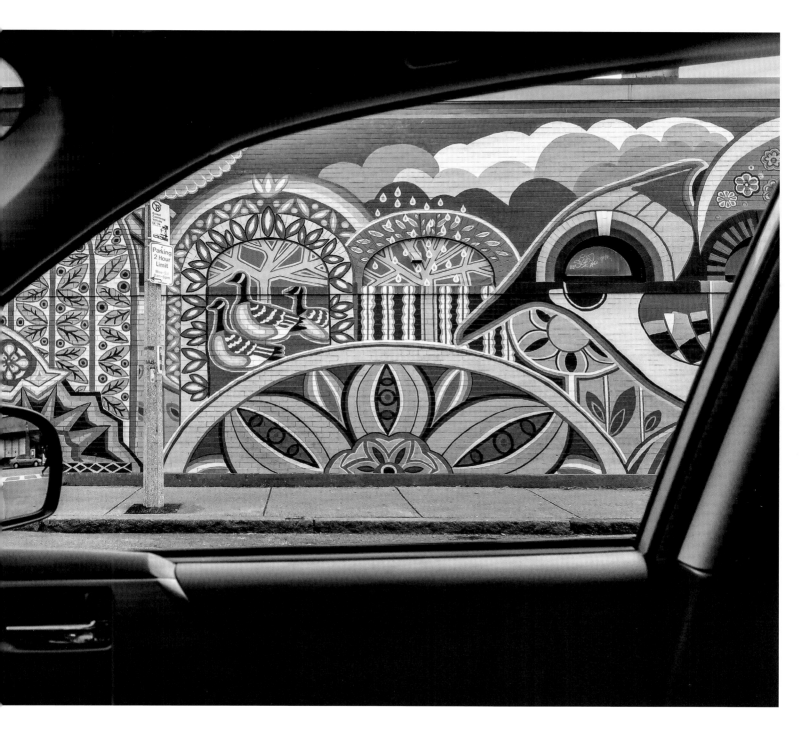

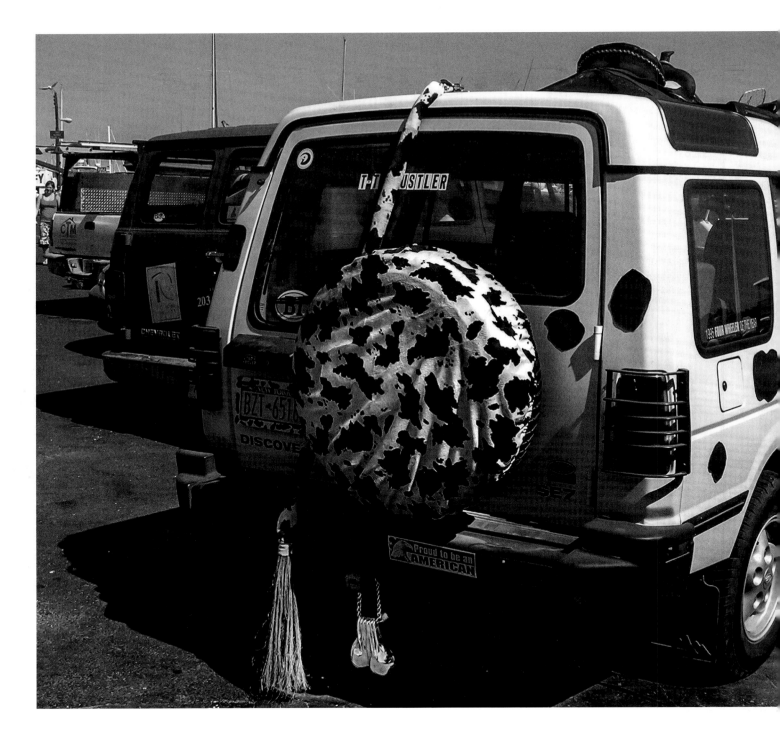

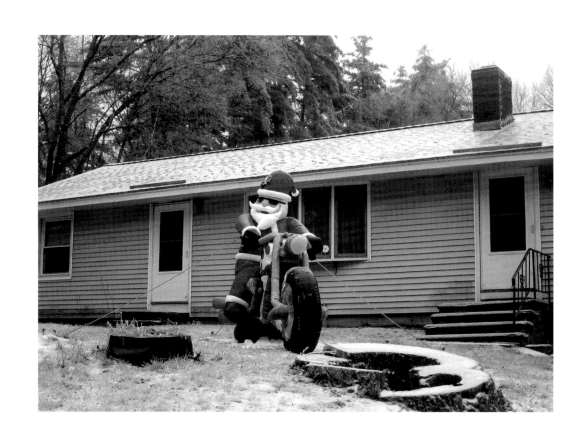

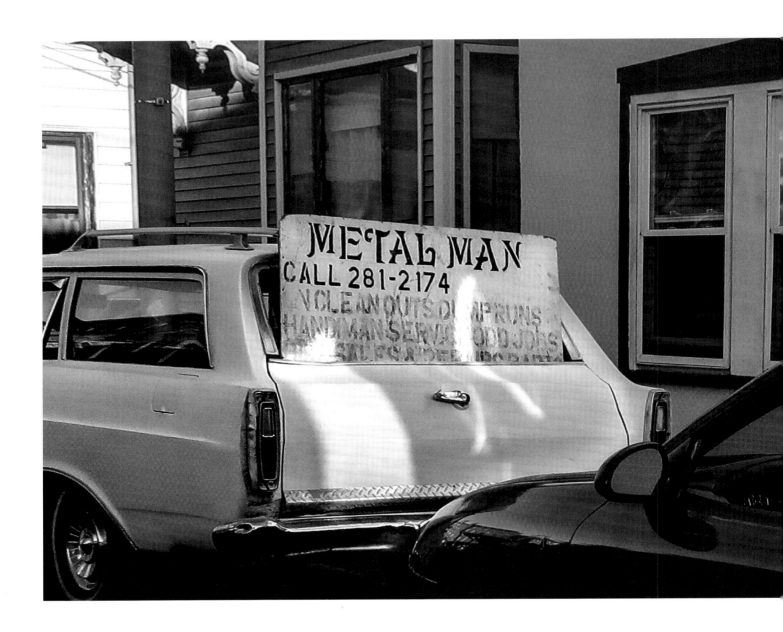

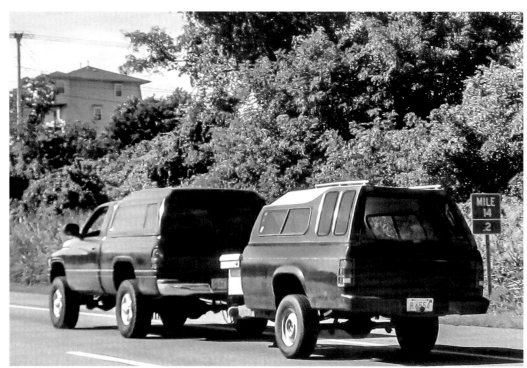

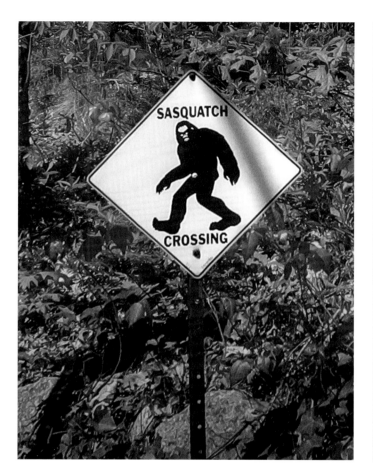

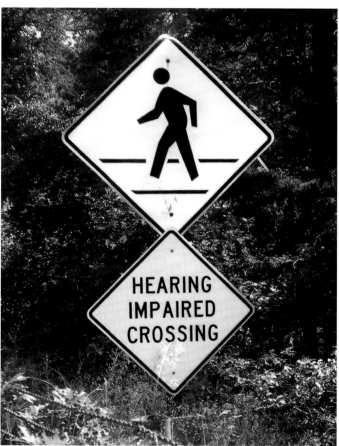

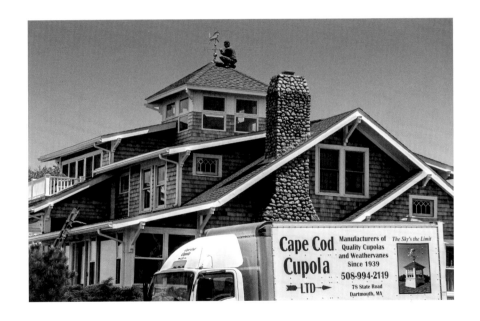

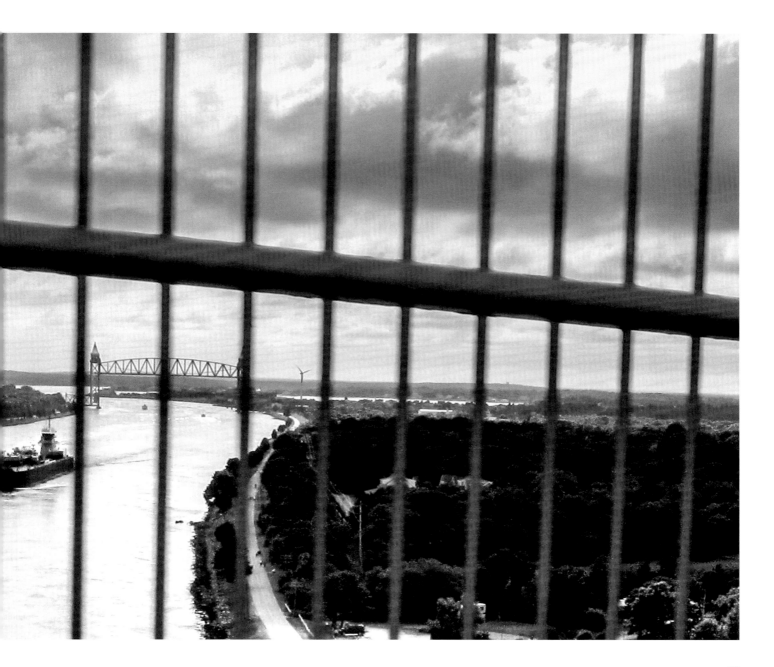

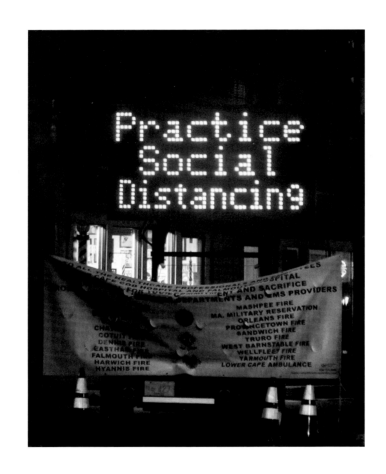

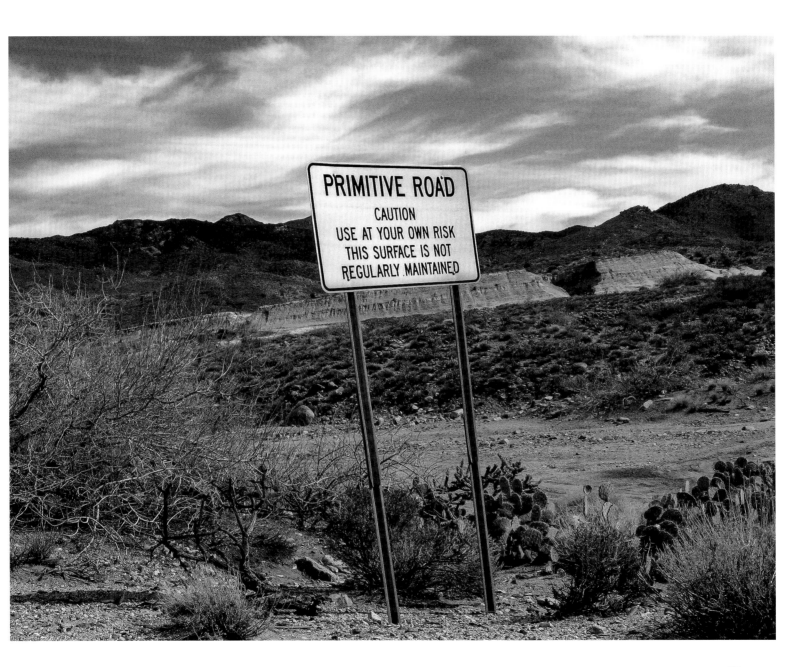

PRIMITIVE ROAD
CAUTION
USE AT YOUR OWN RISK
THIS SURFACE IS NOT
REGULARLY MAINTAINED

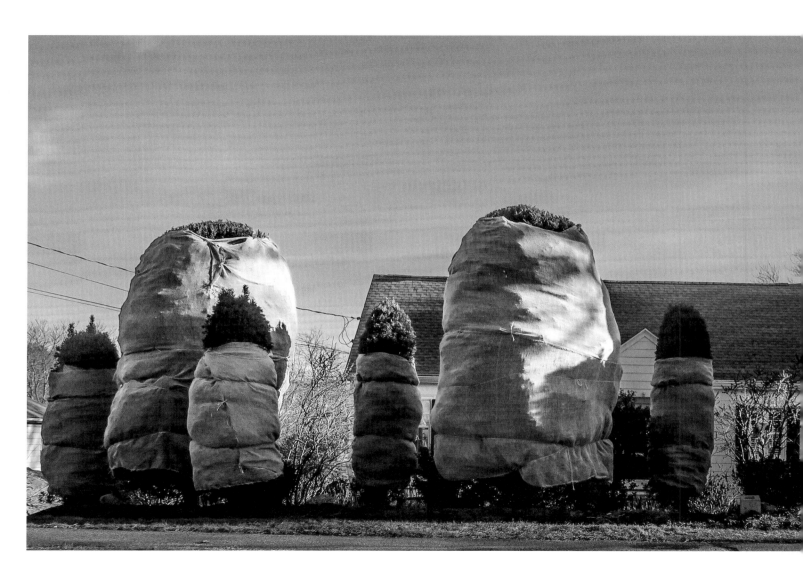

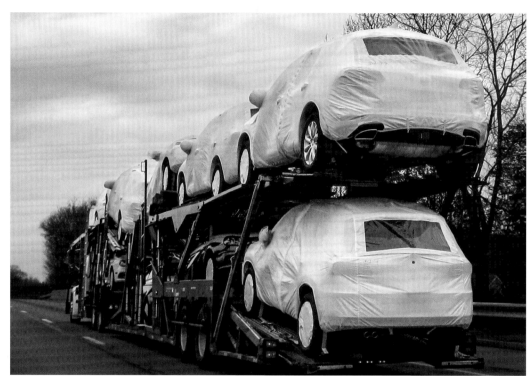

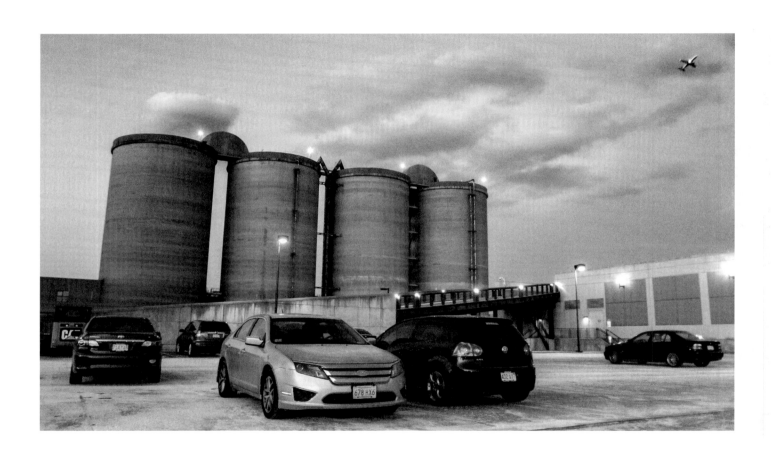

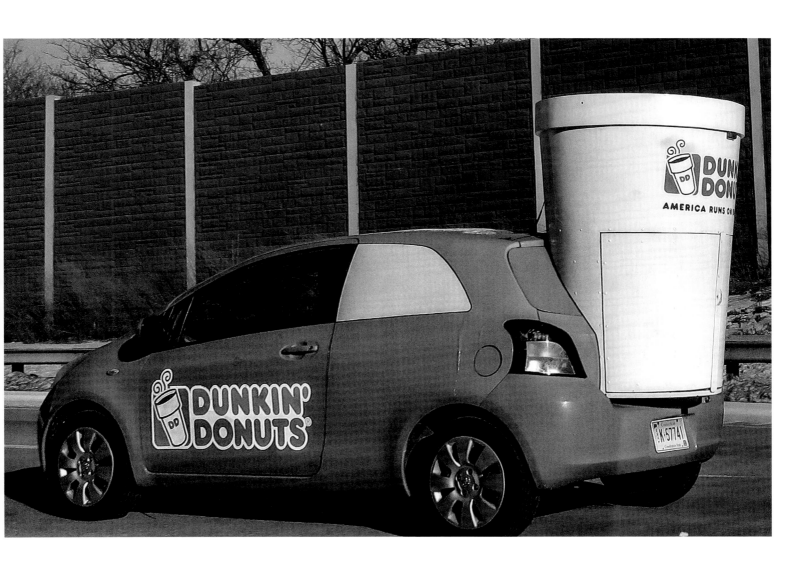

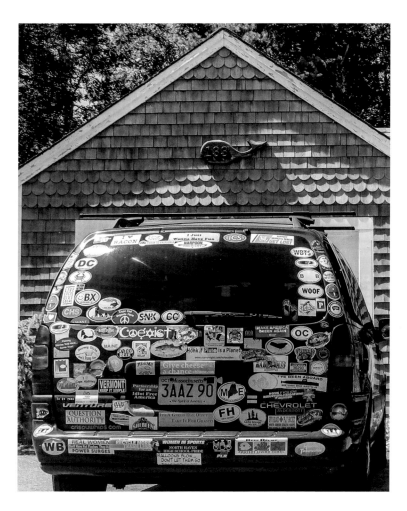

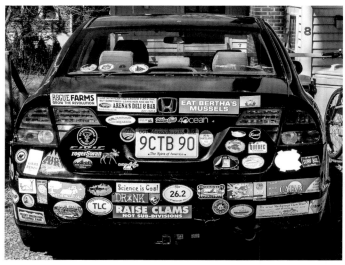

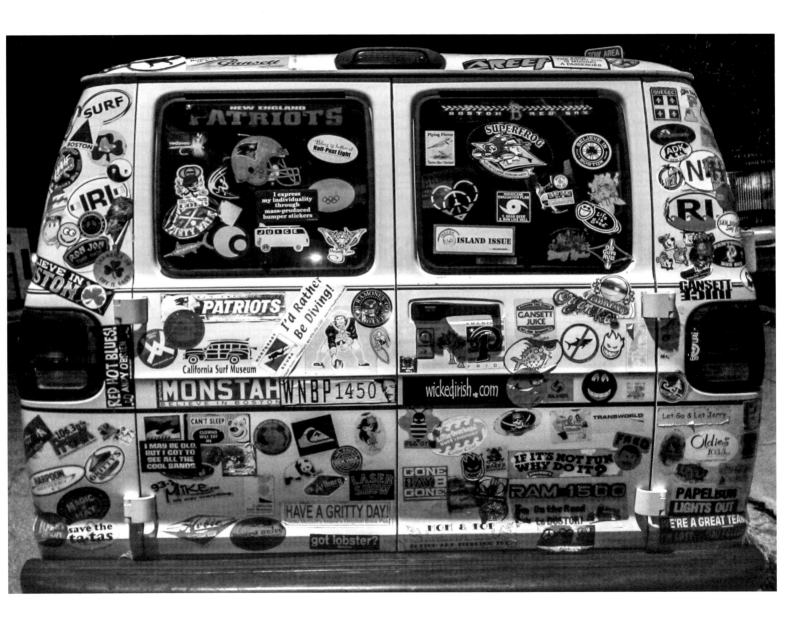

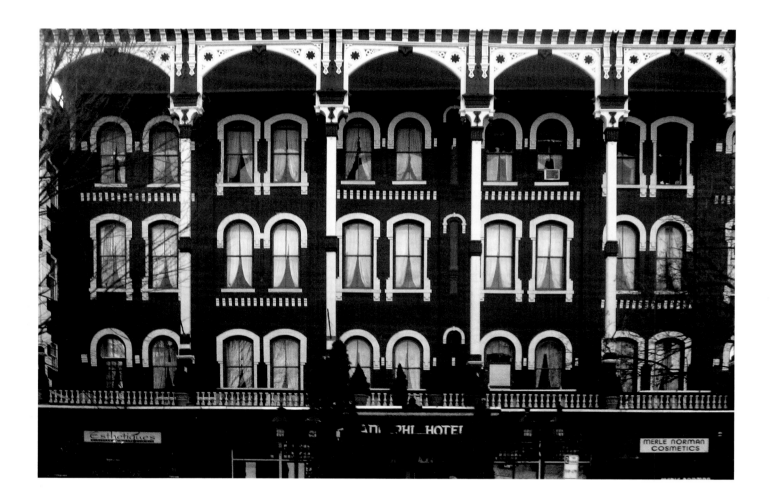

28

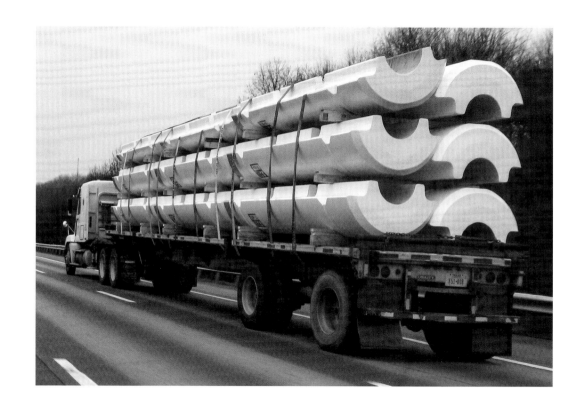

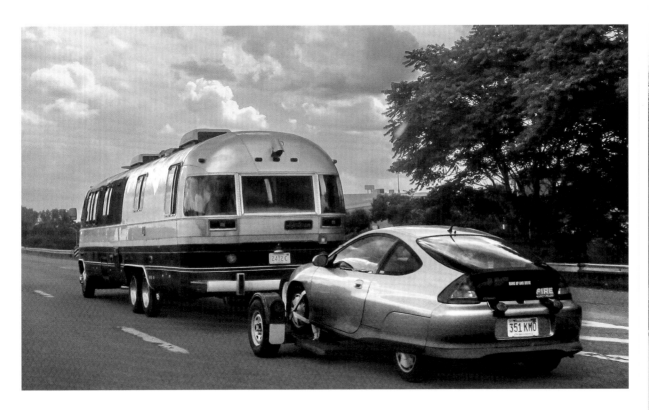

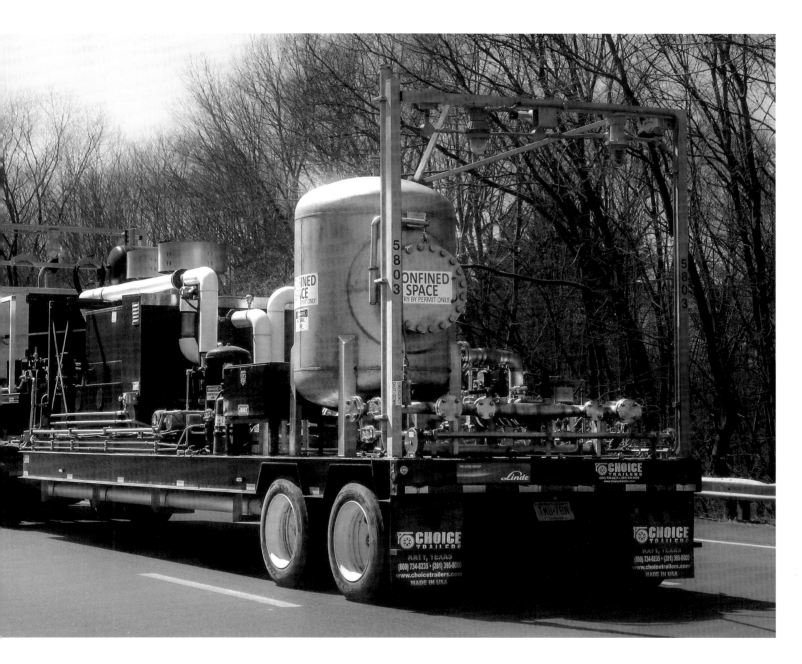

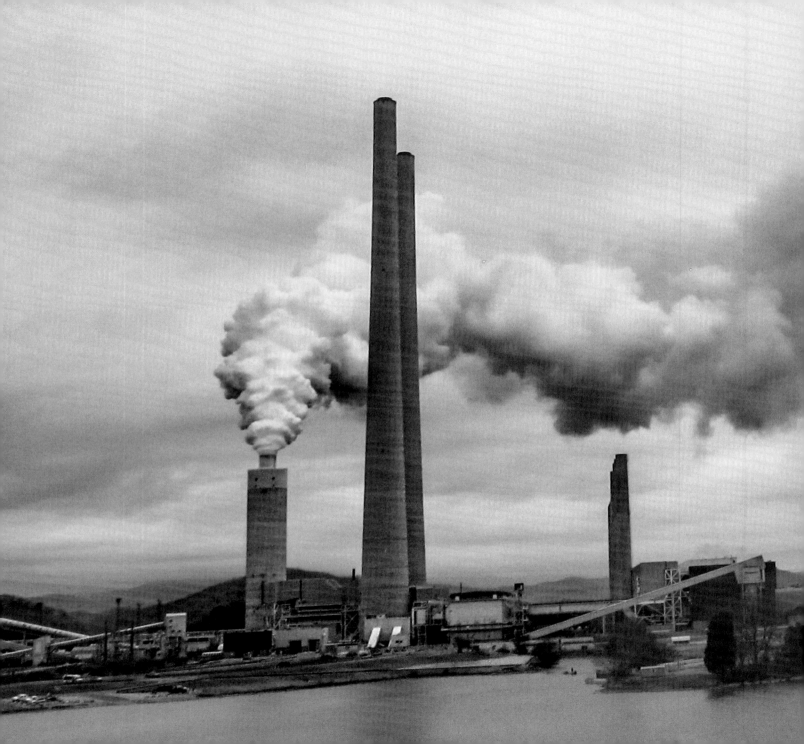

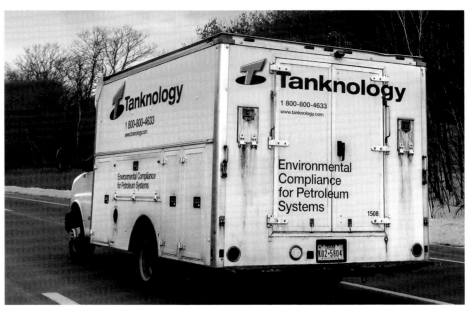

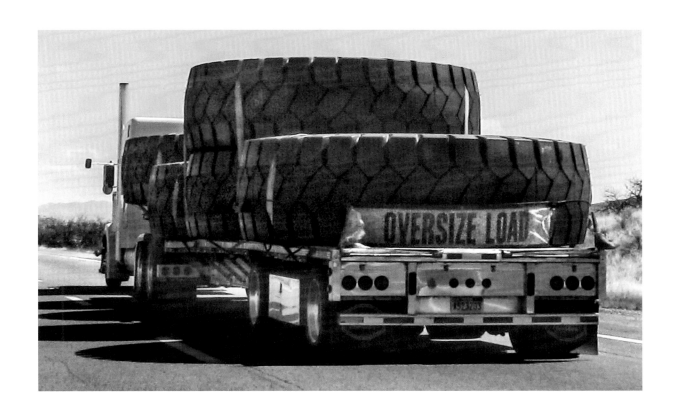

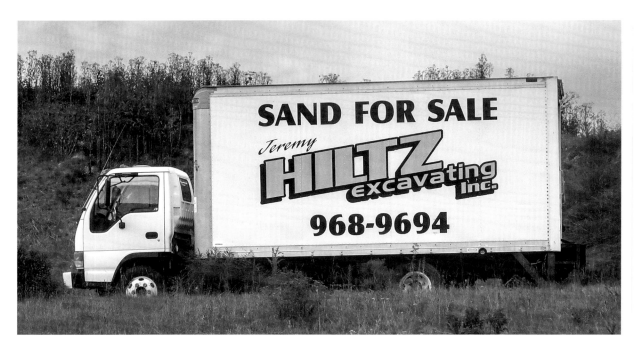

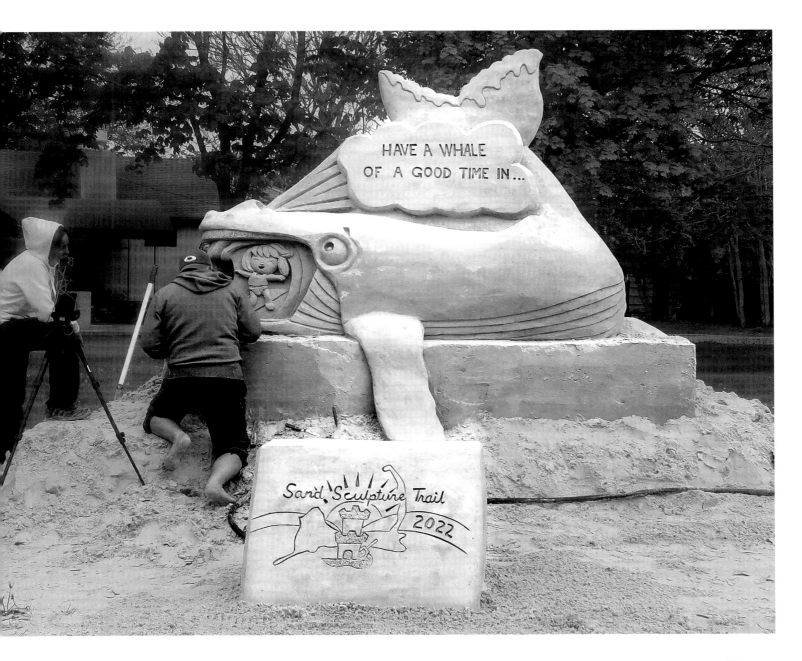

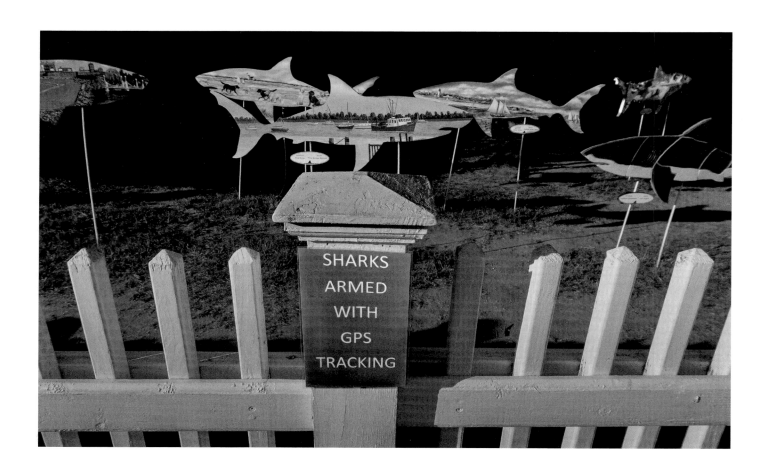

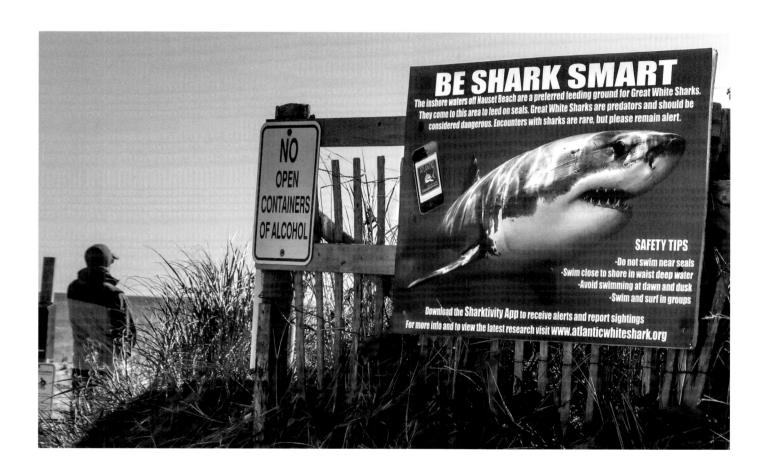

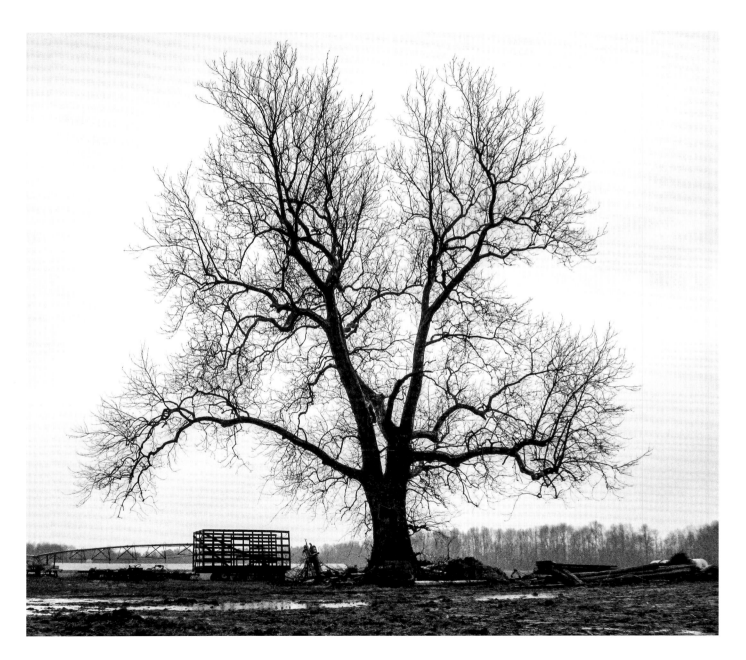

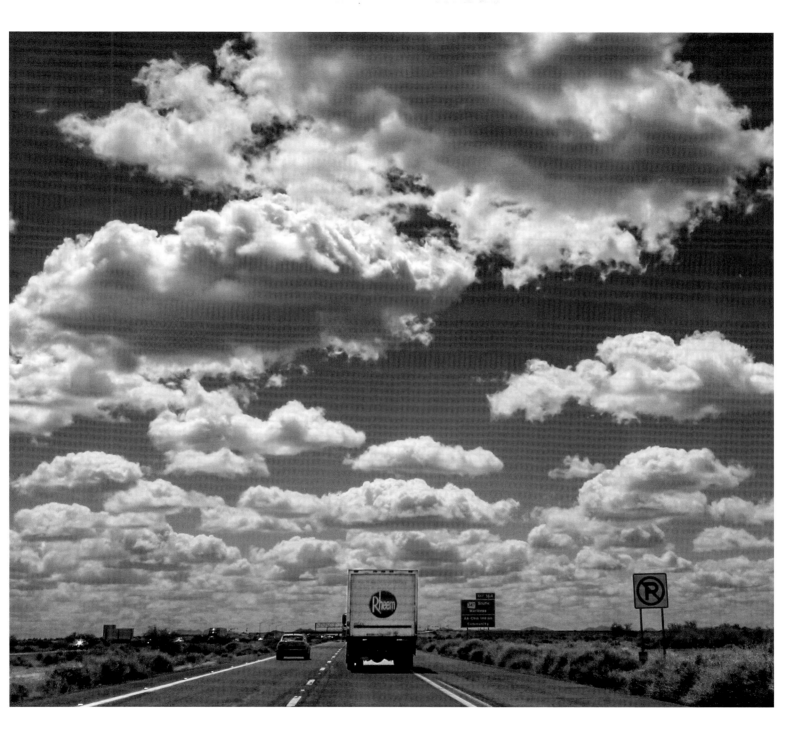

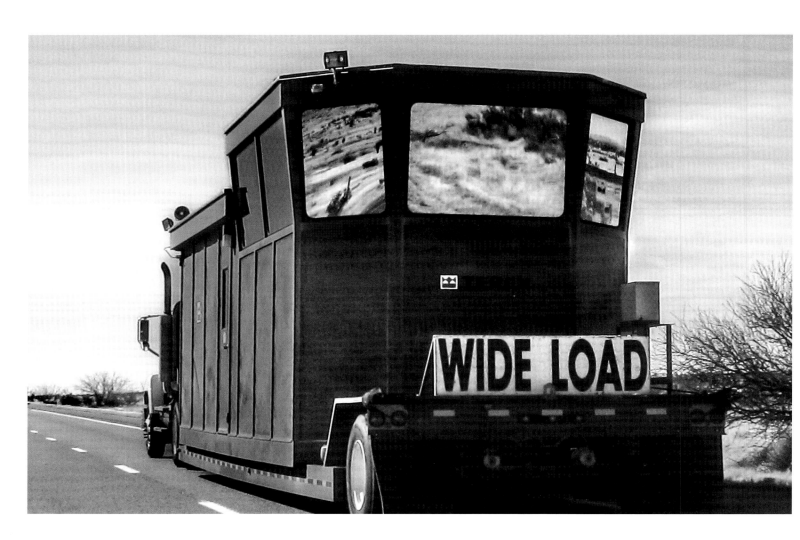

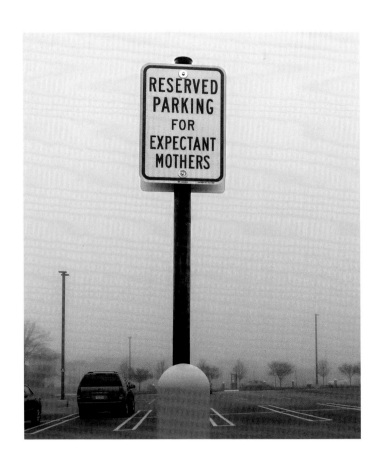

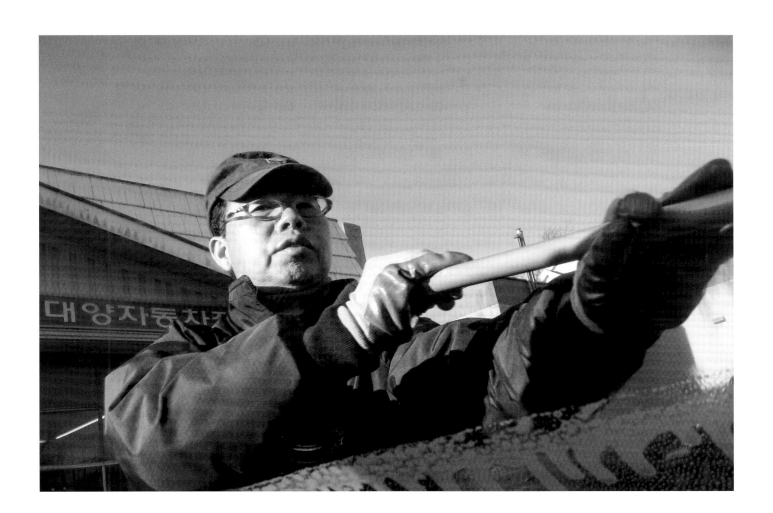

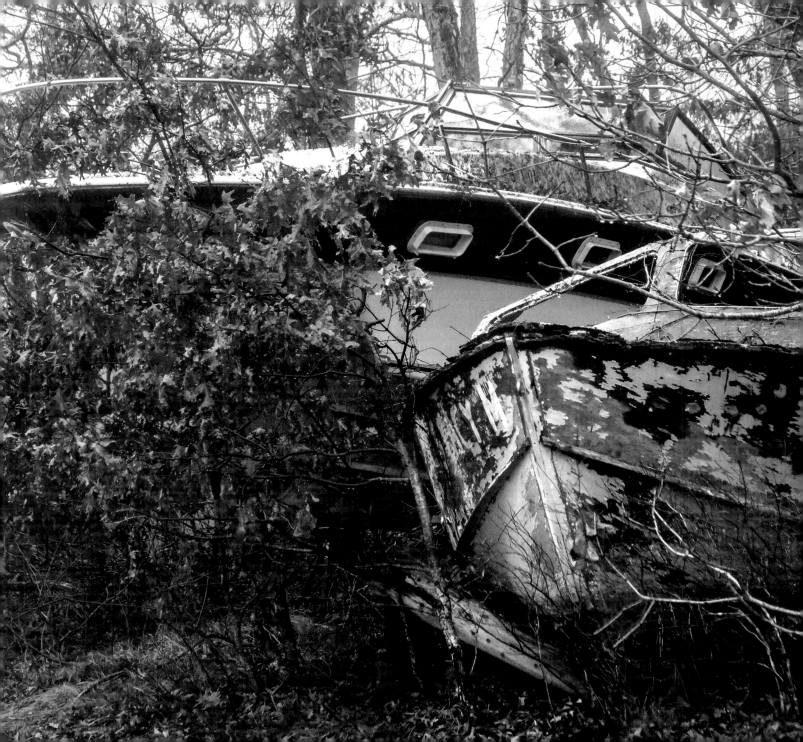

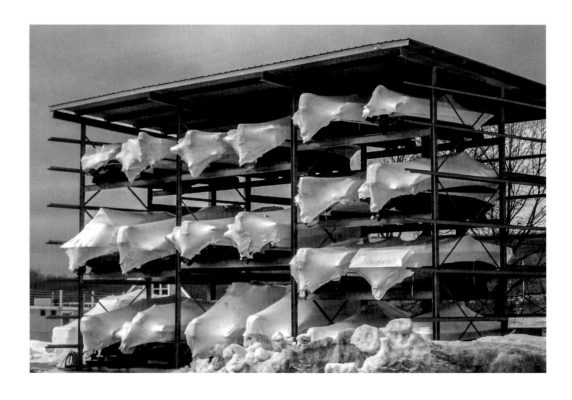

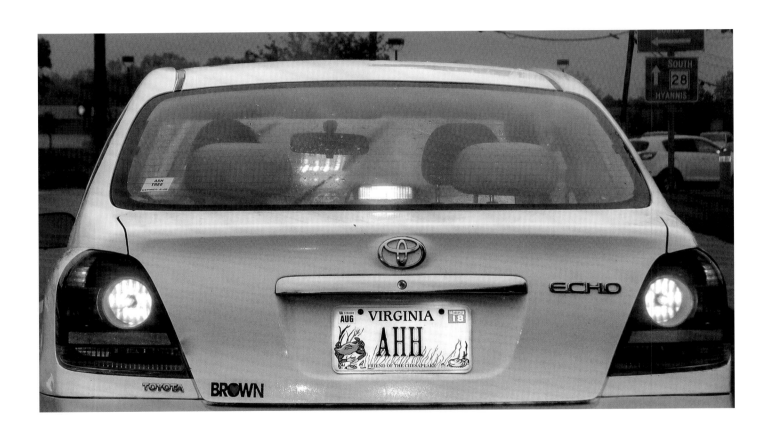

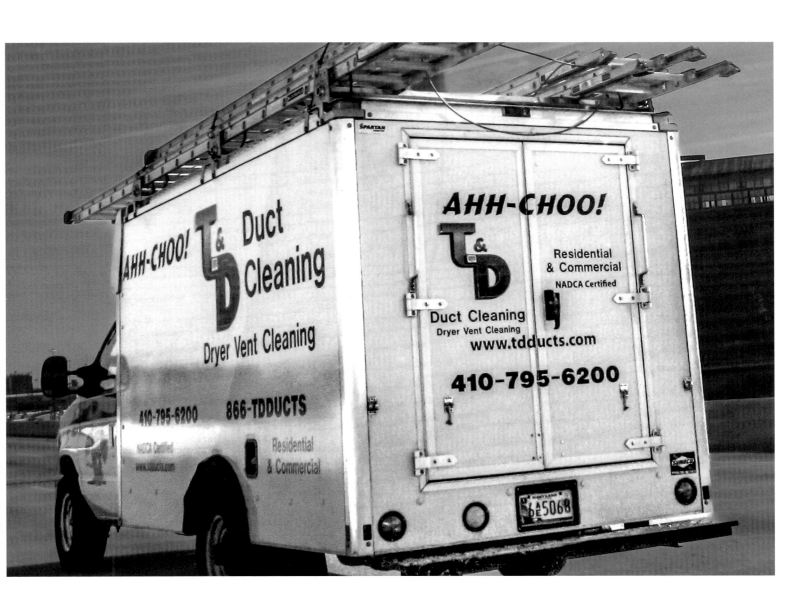

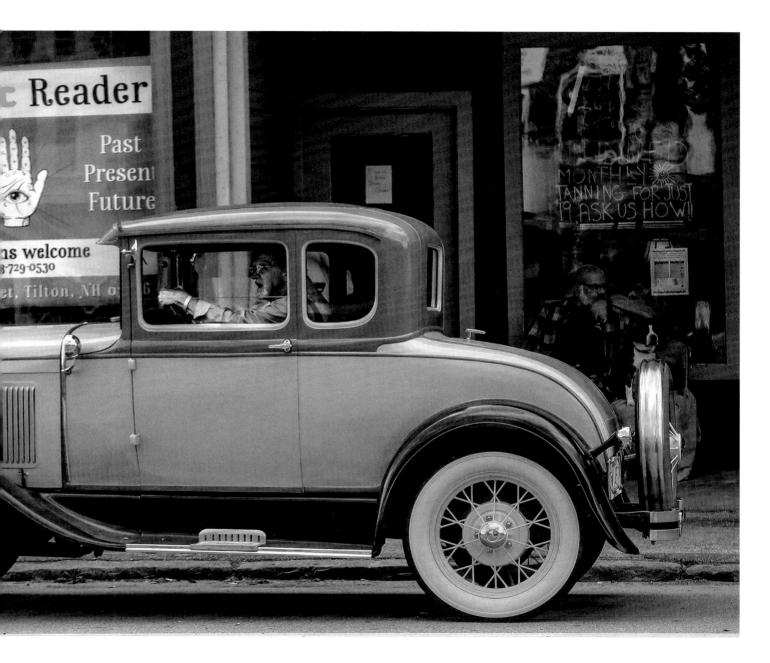

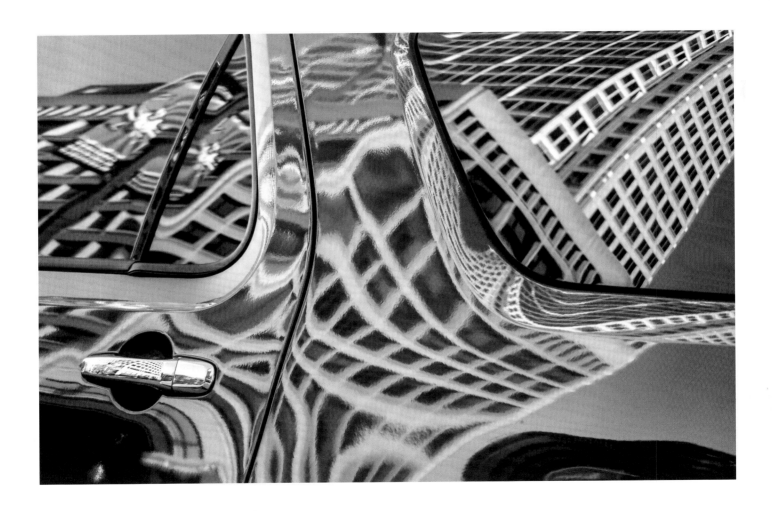

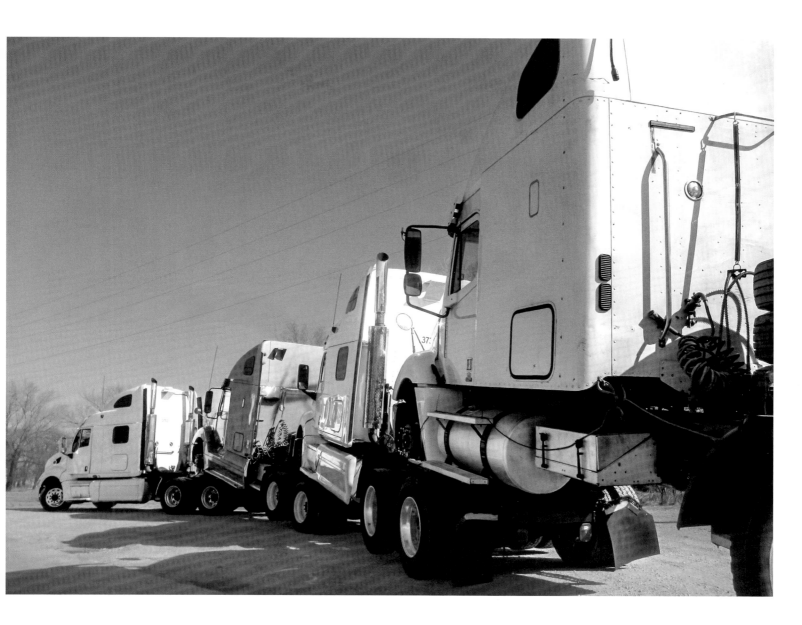

West Falmouth
United Methodist Church
founded 1897

WORSHIP-9a.m.
Child Care Available

Sieglinde Rogers,
PASTOR

All Welcome

BLESSING
OF
BICYCLES
JULY 2
11 - 1

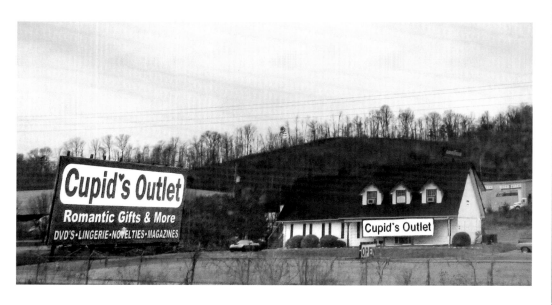

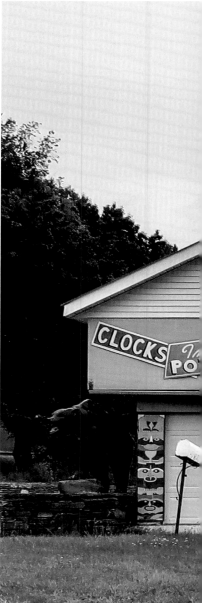

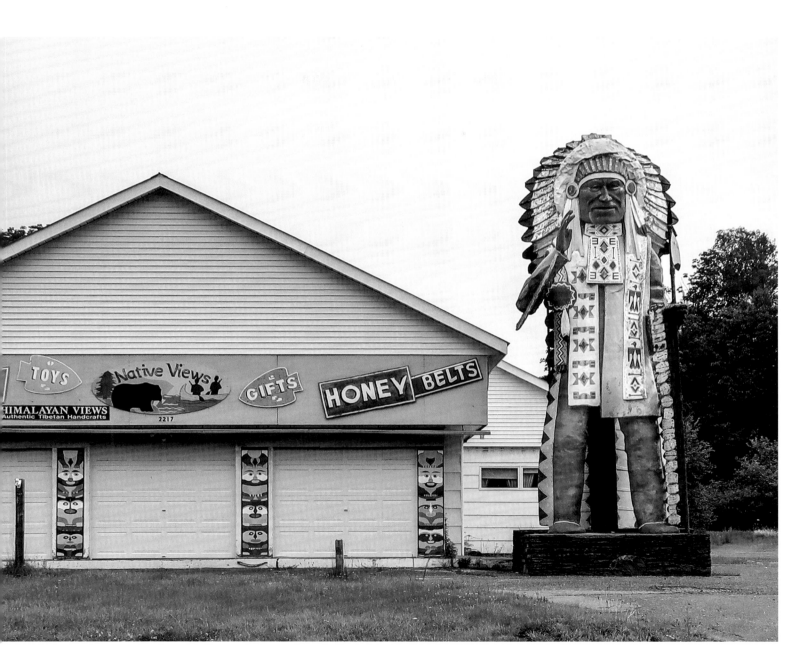

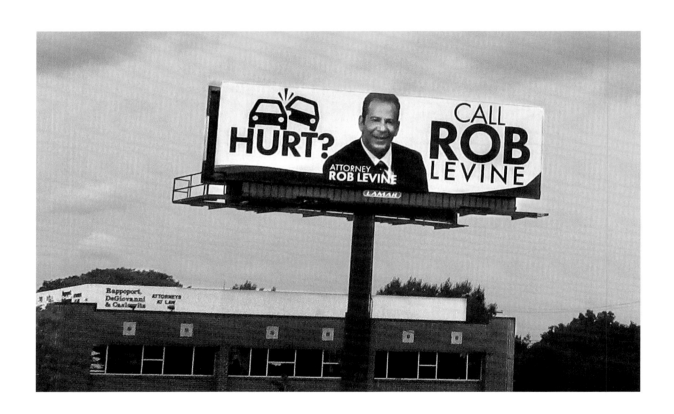

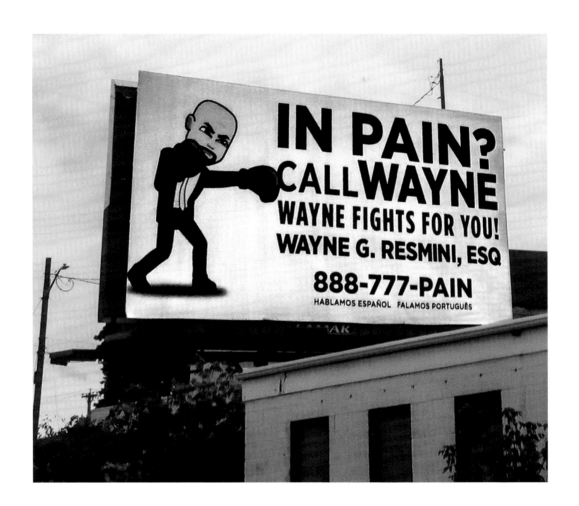

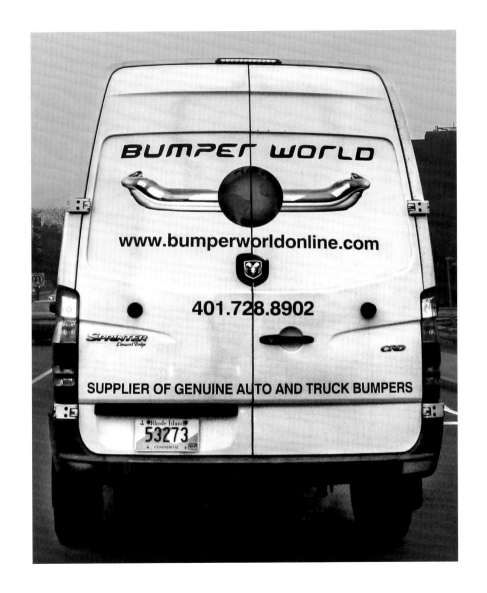

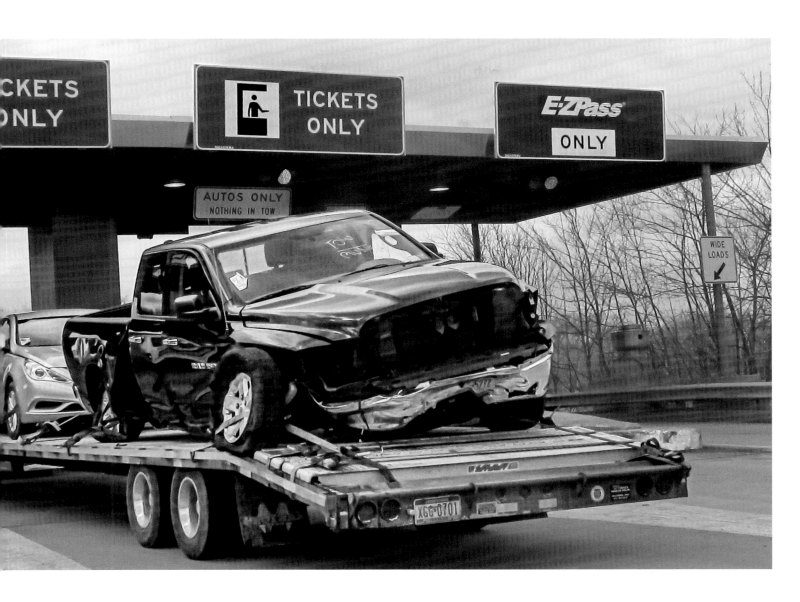

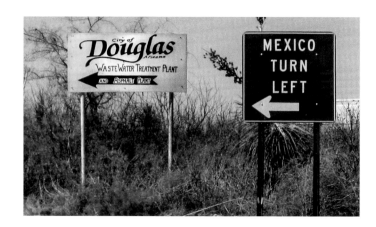

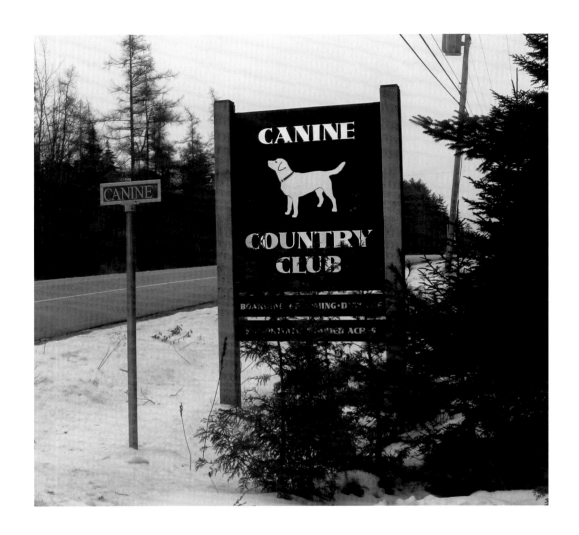

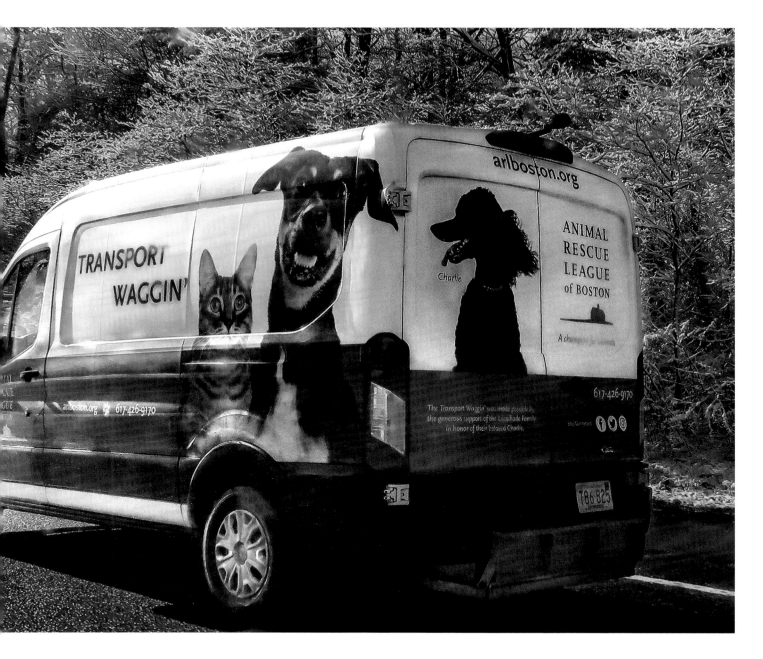

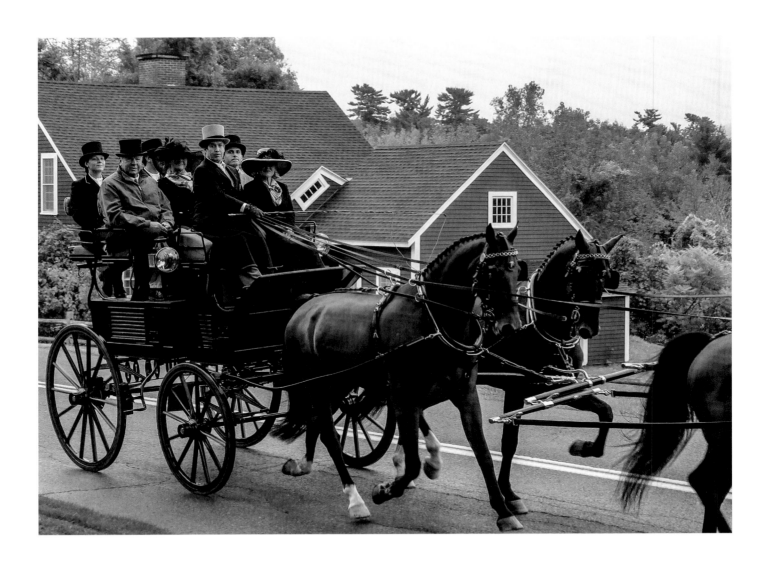

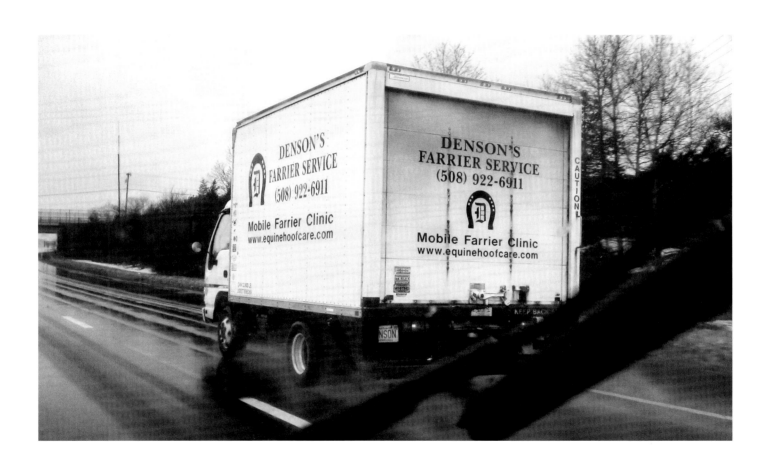

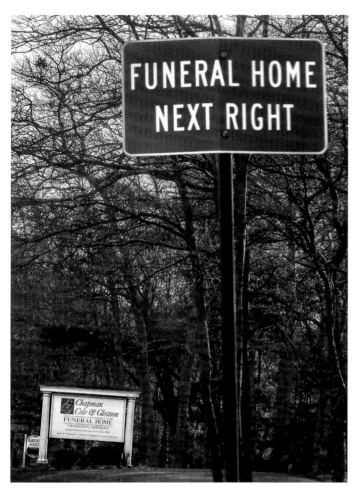

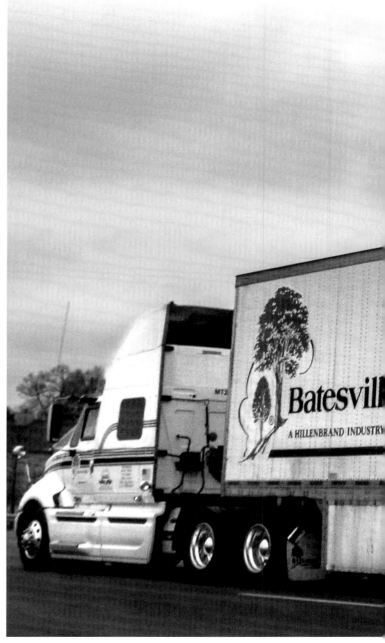

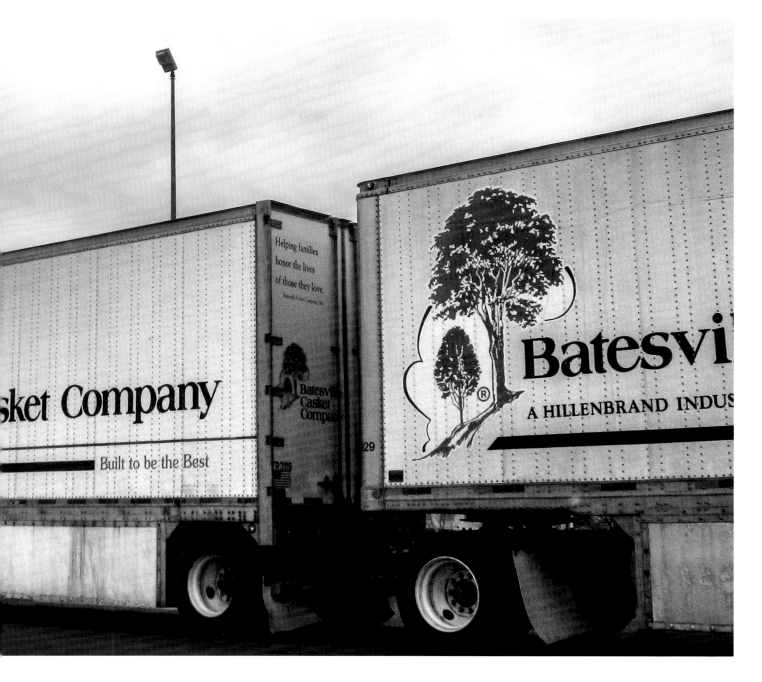

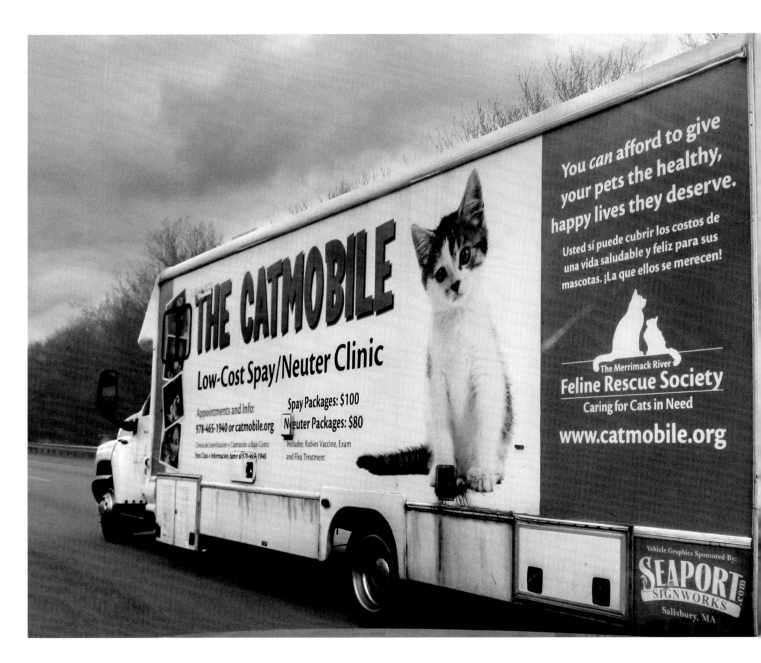

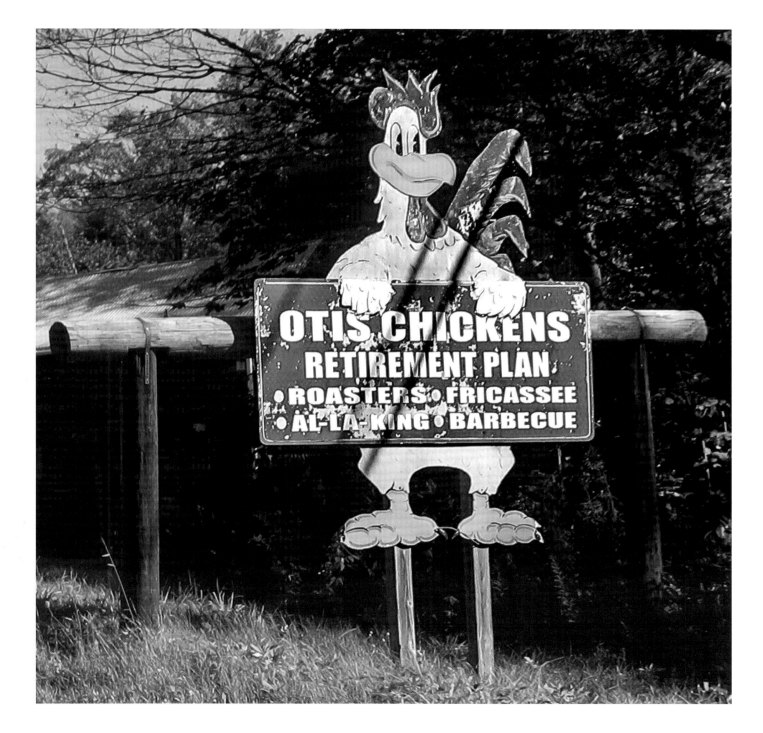

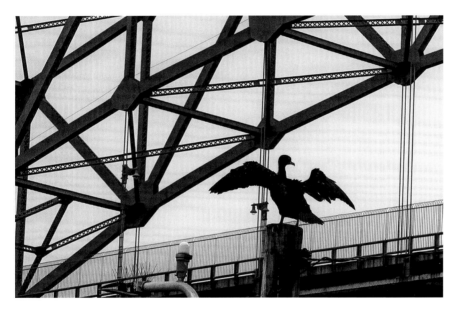

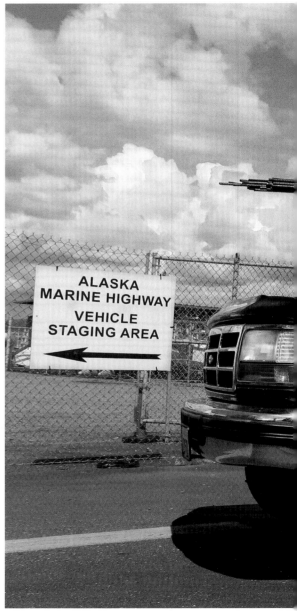

ALASKA
MARINE HIGHWAY

VEHICLE
STAGING AREA

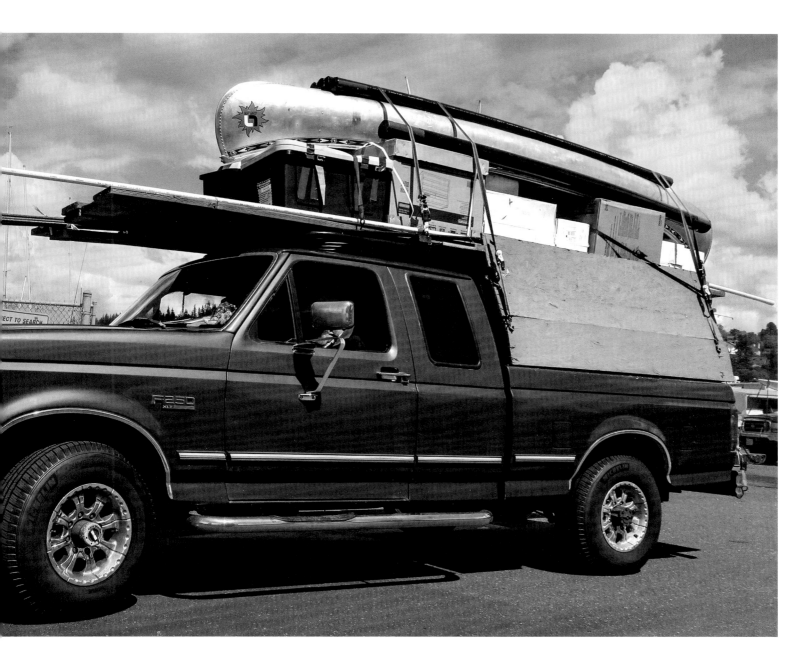

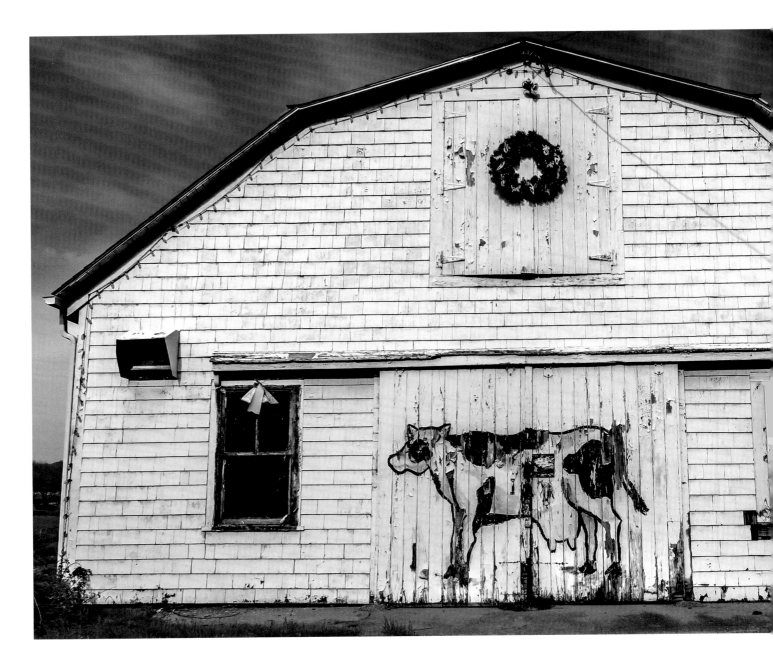

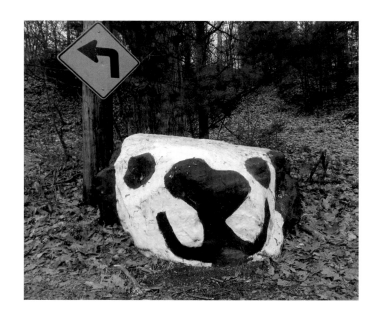

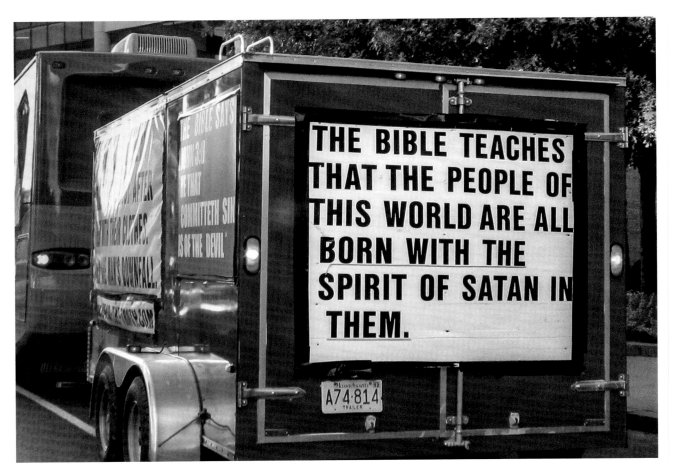

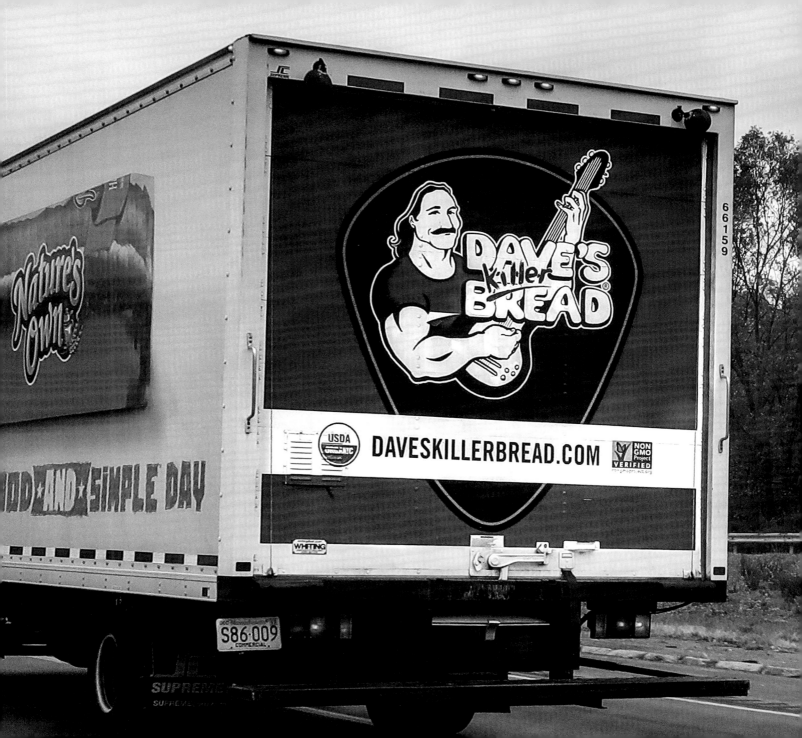

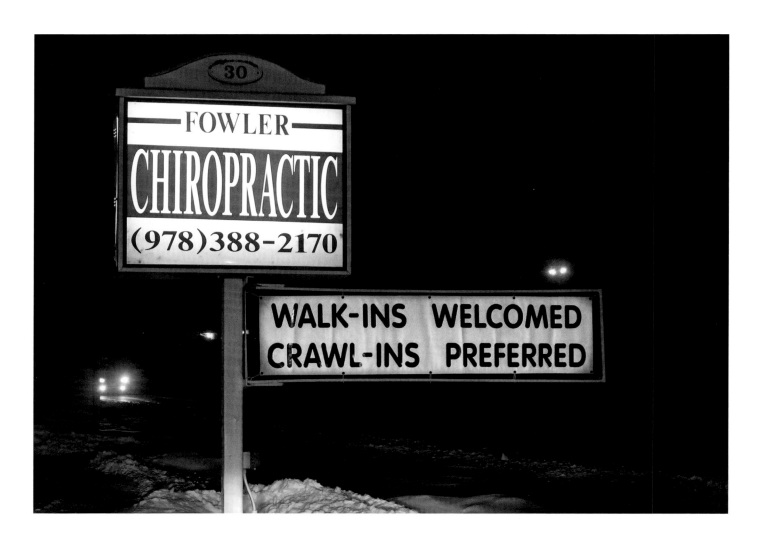

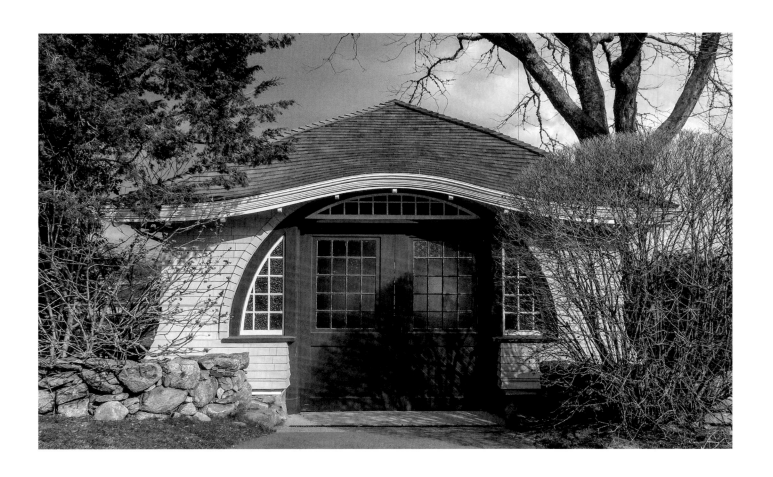

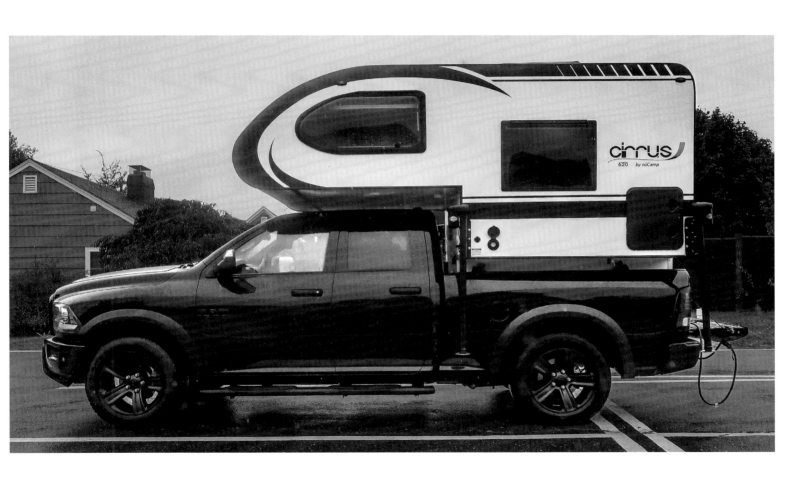

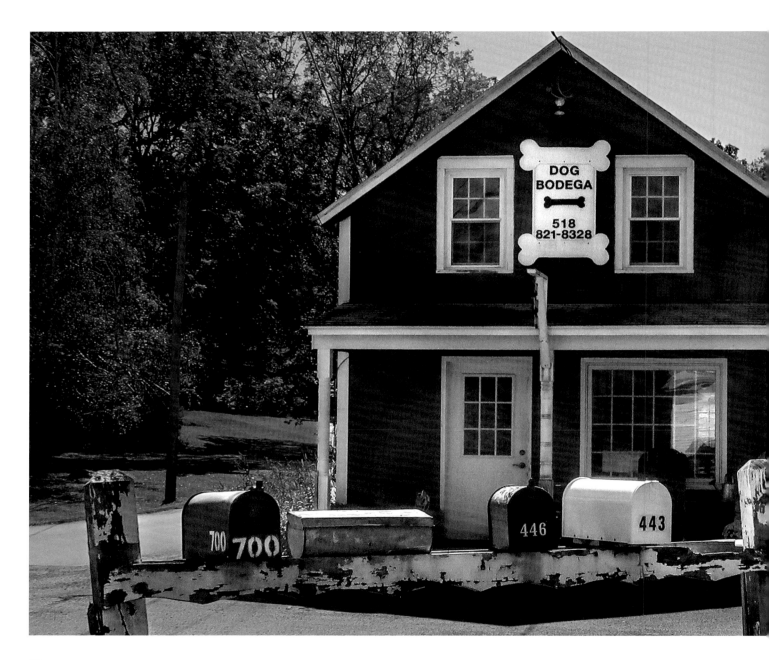

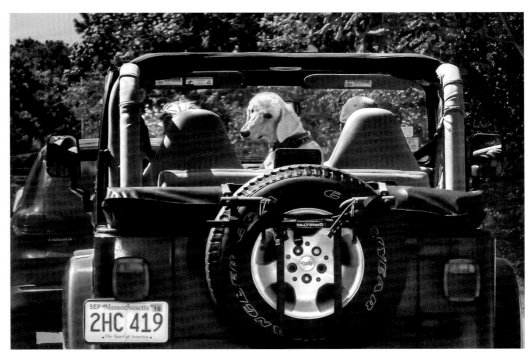

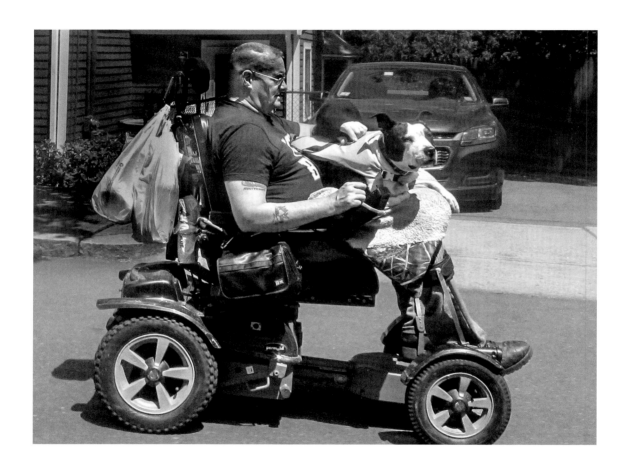

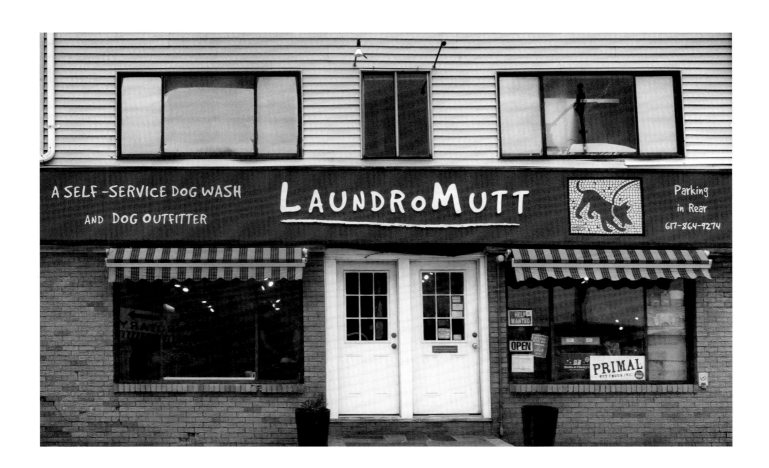

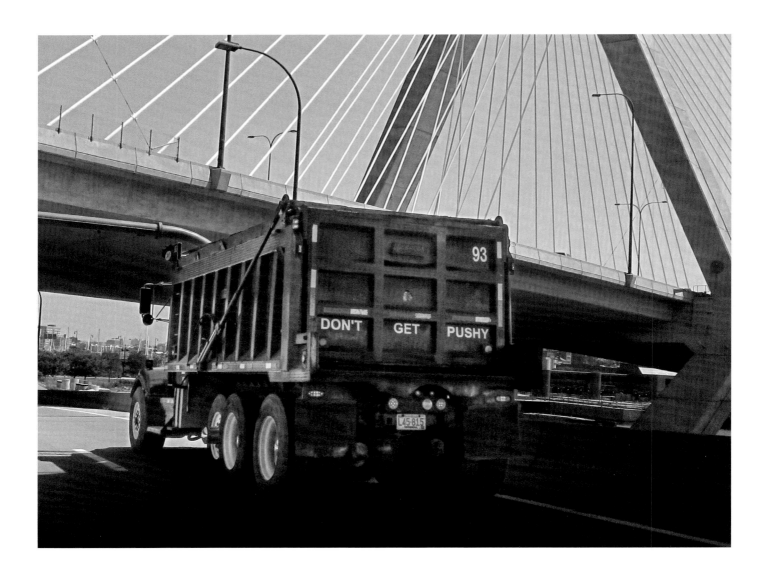

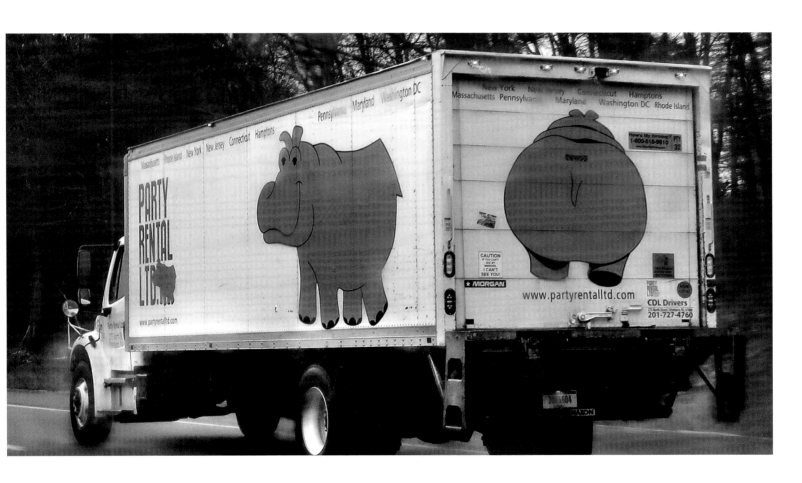

93

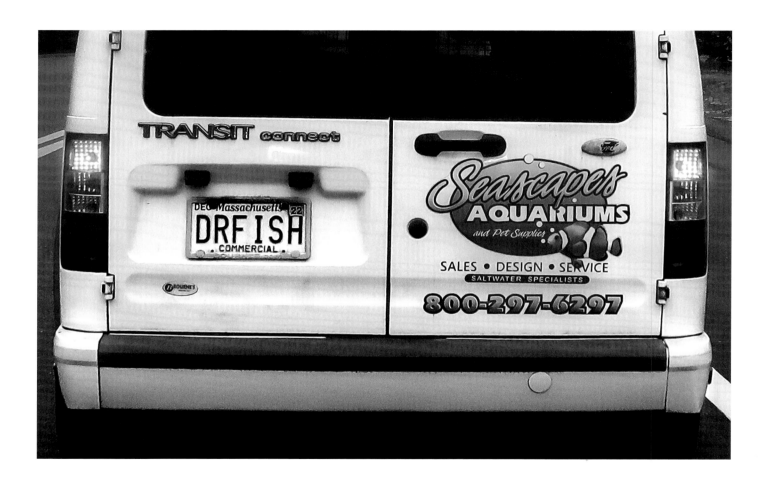

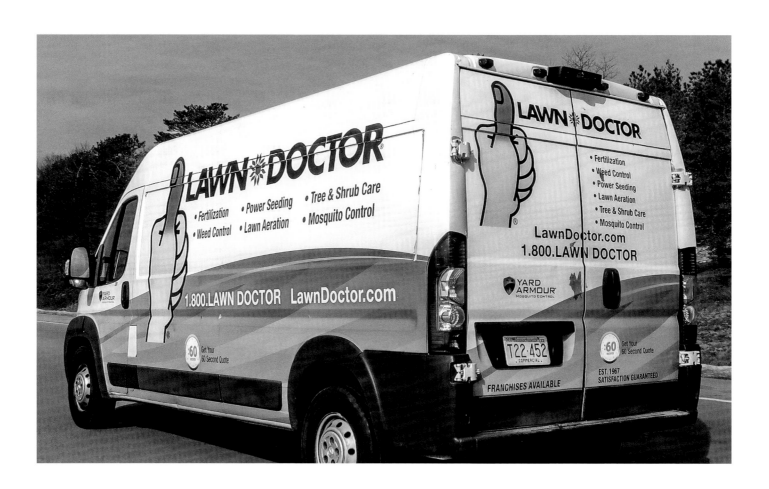

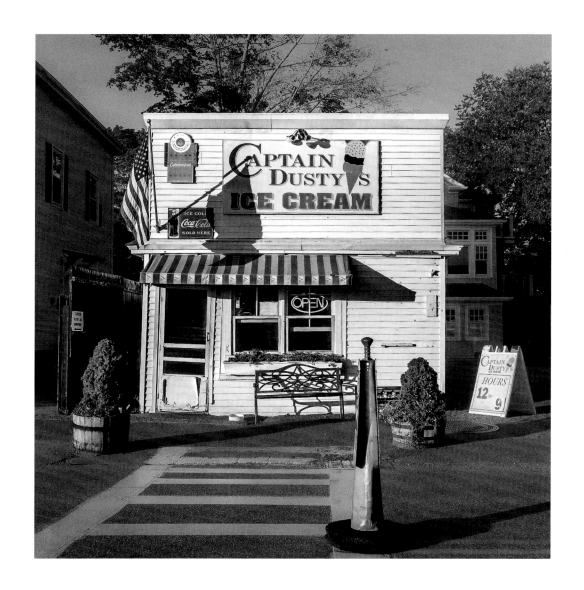

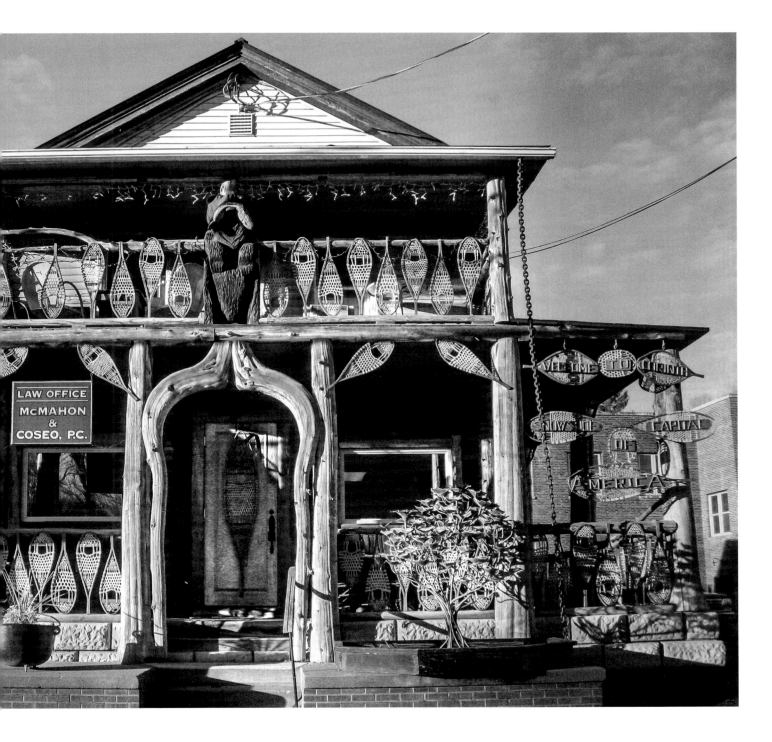

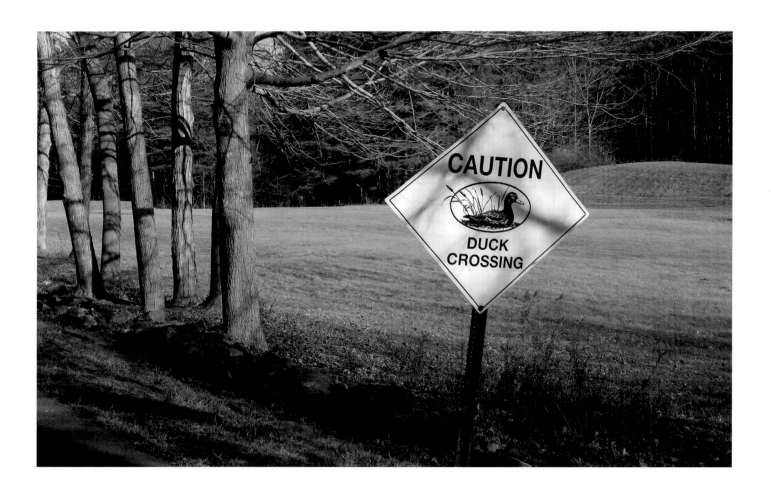

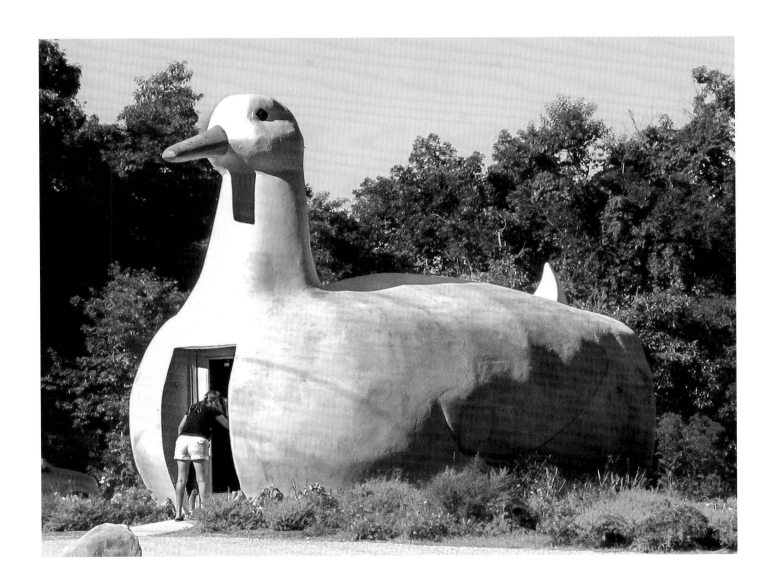

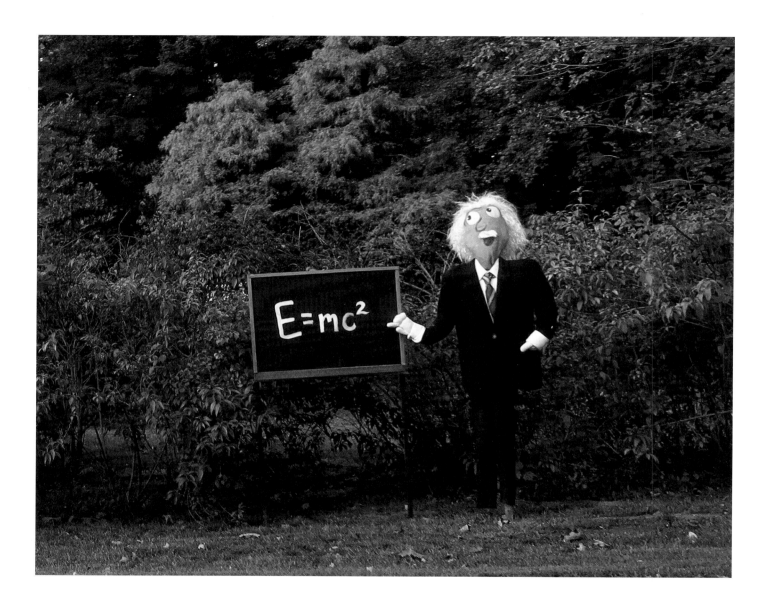

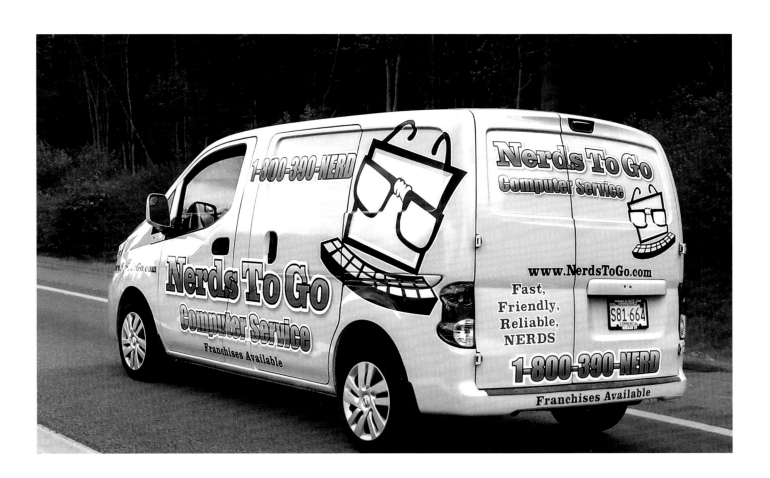

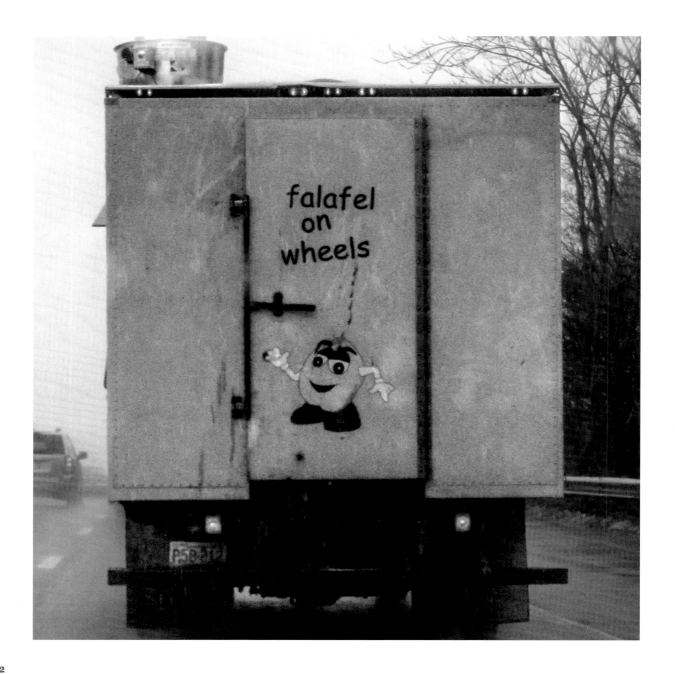

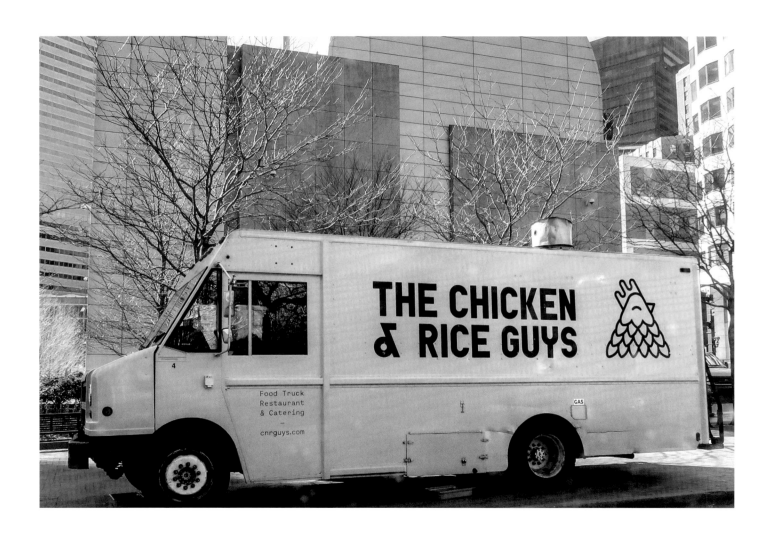

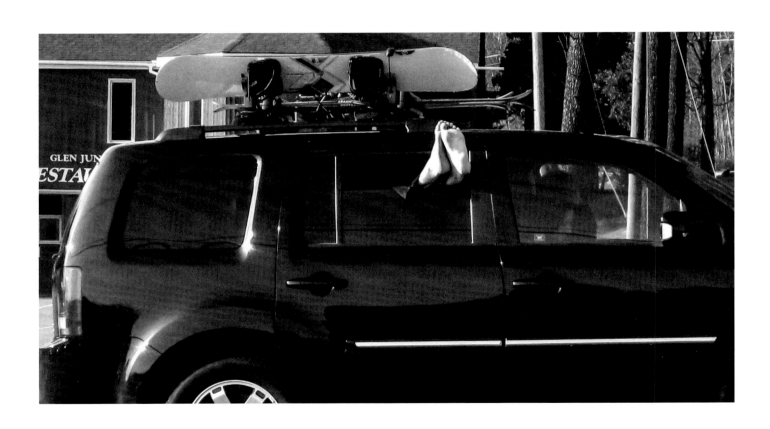

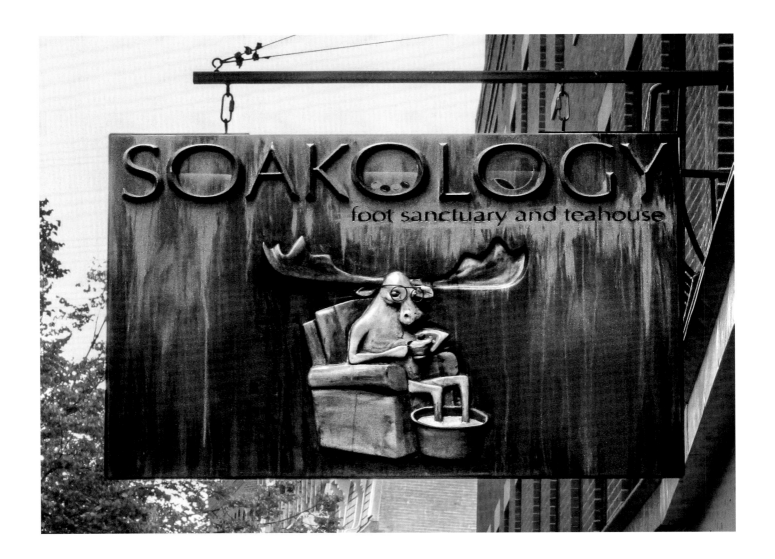

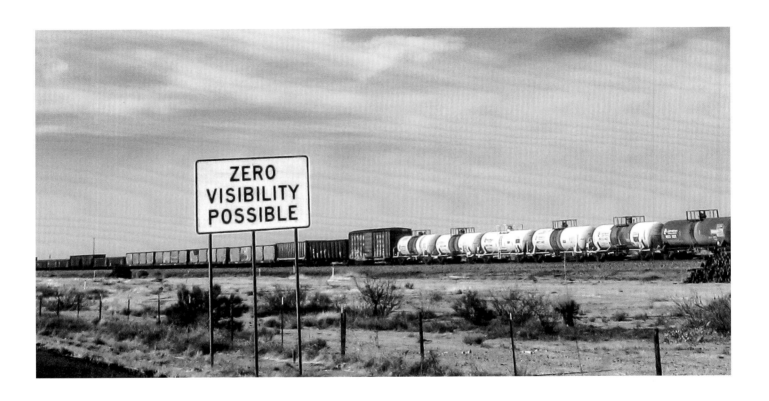

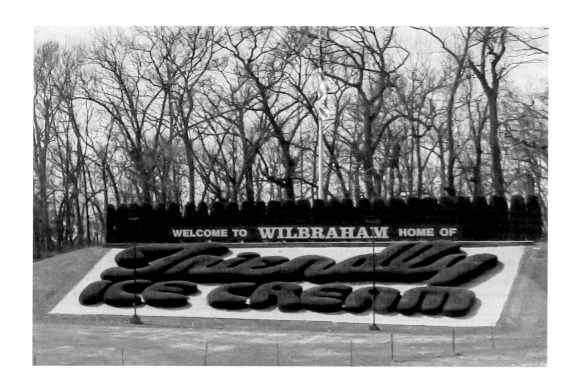

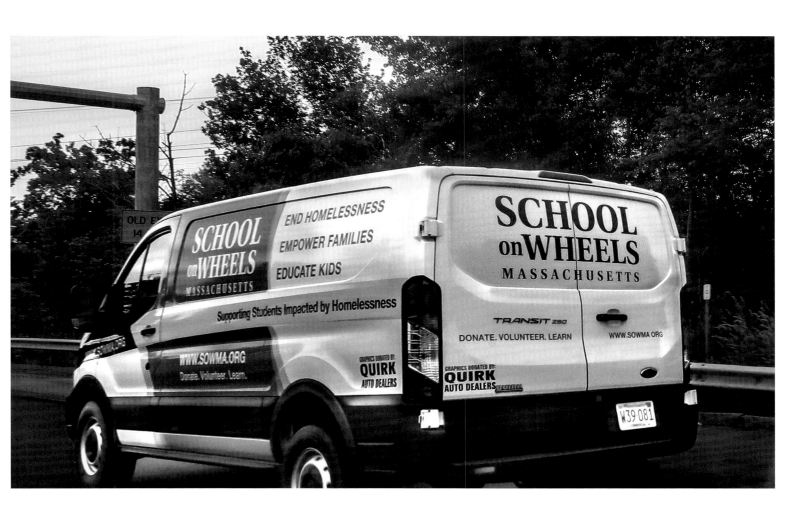

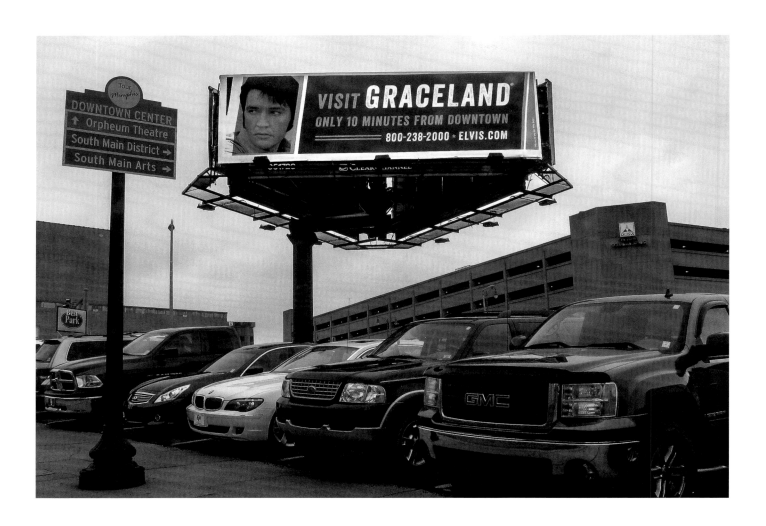

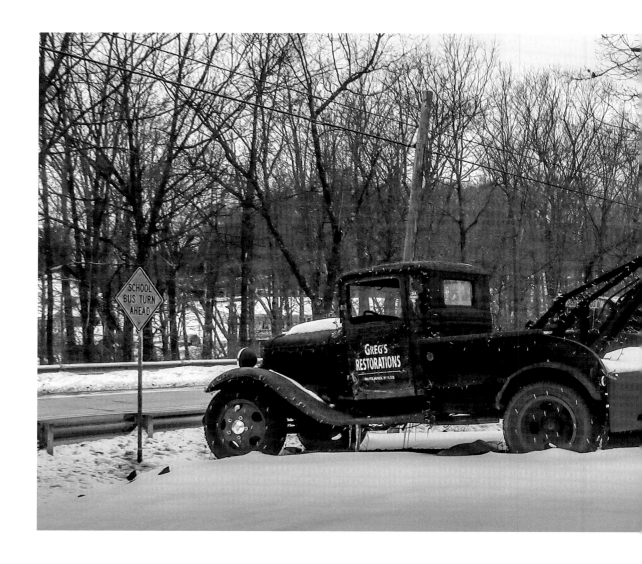

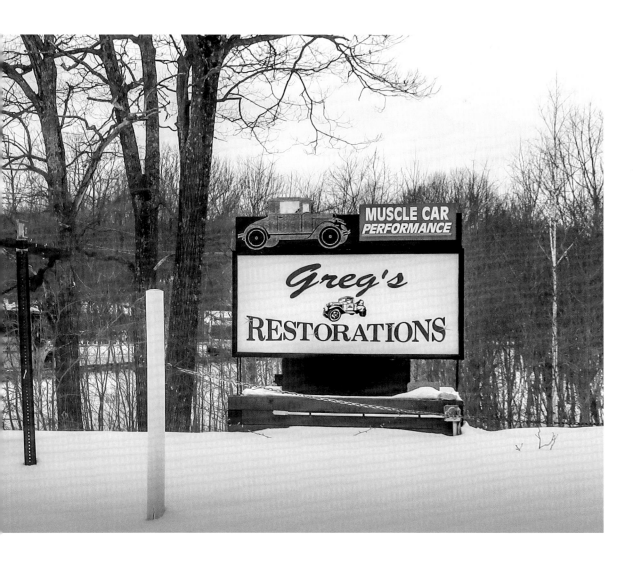

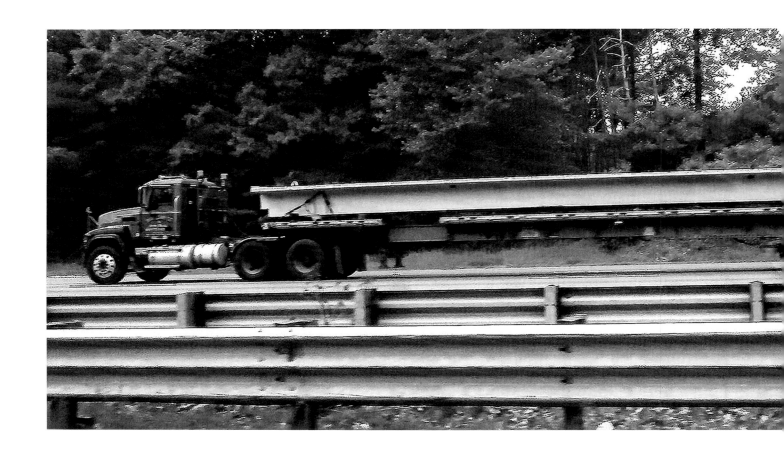

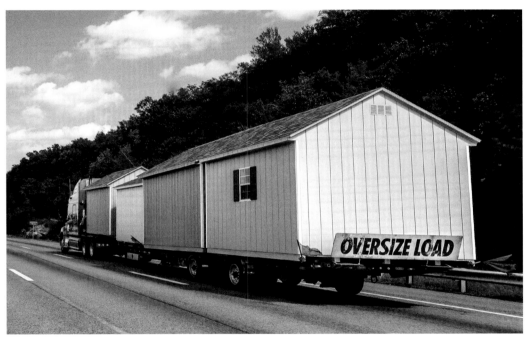

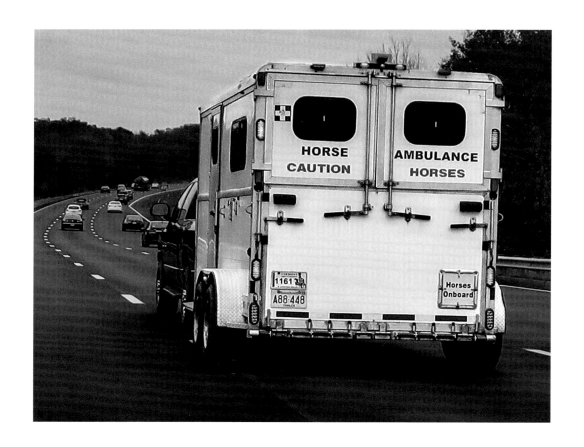

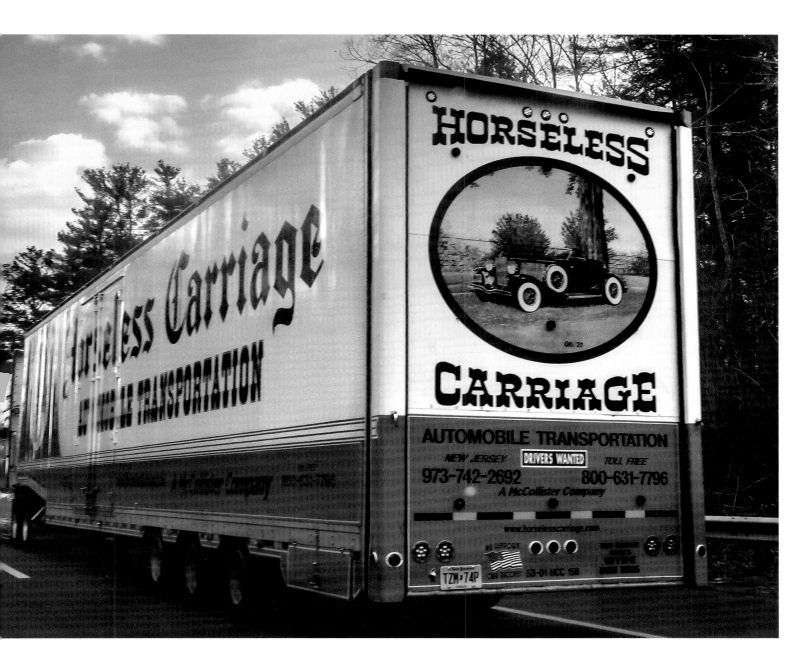

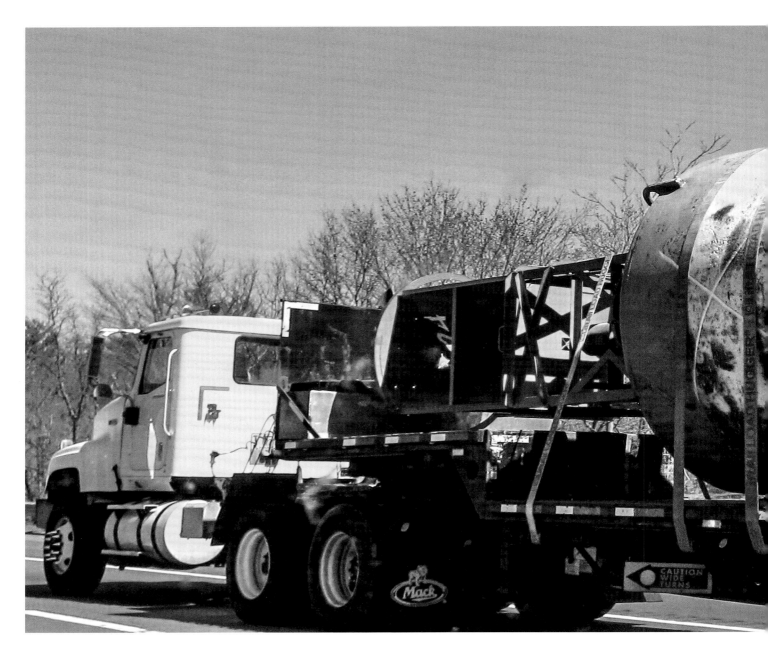

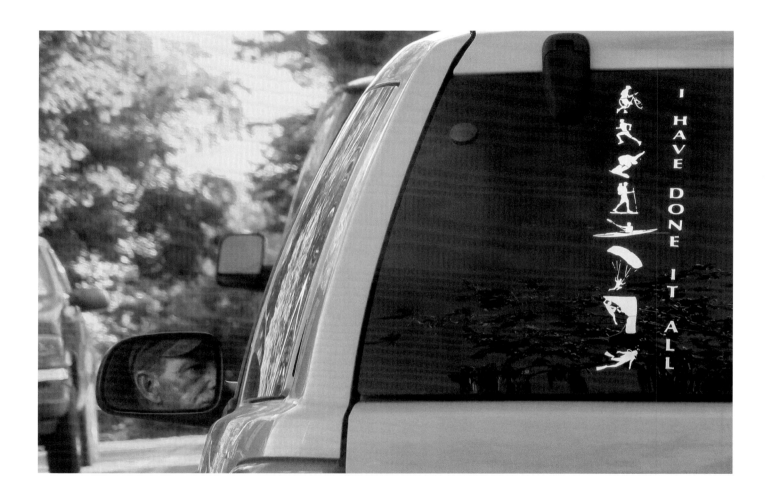

I HAVE DONE IT ALL

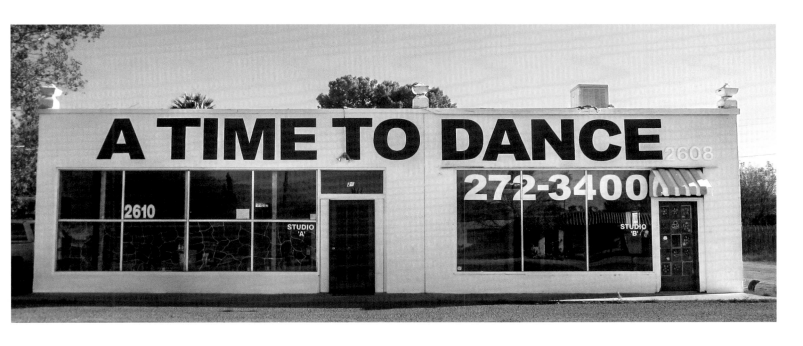

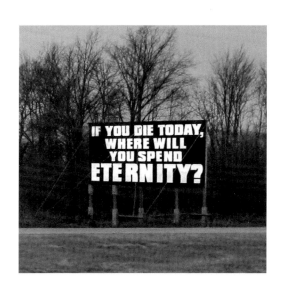

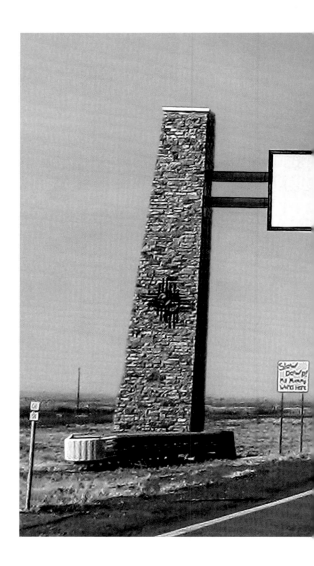

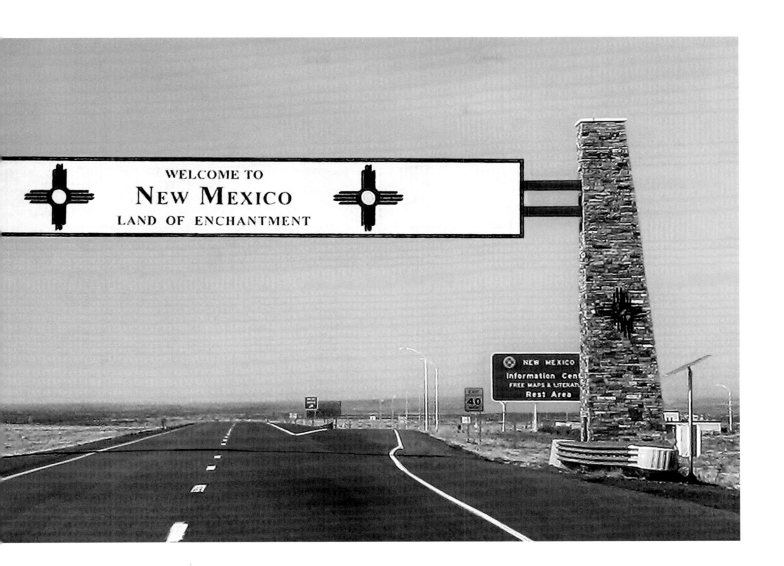

134

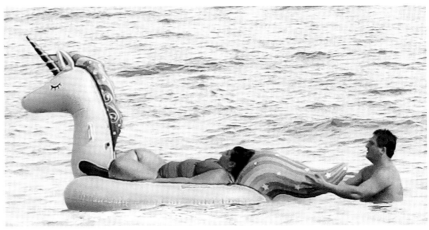

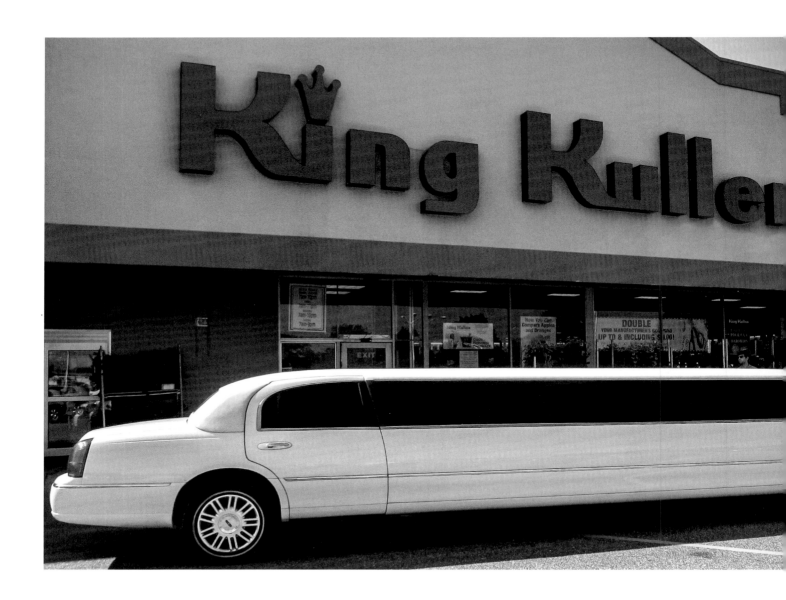

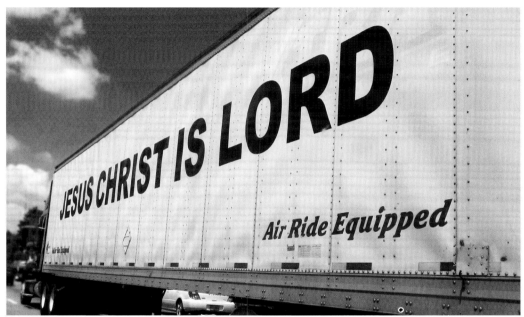

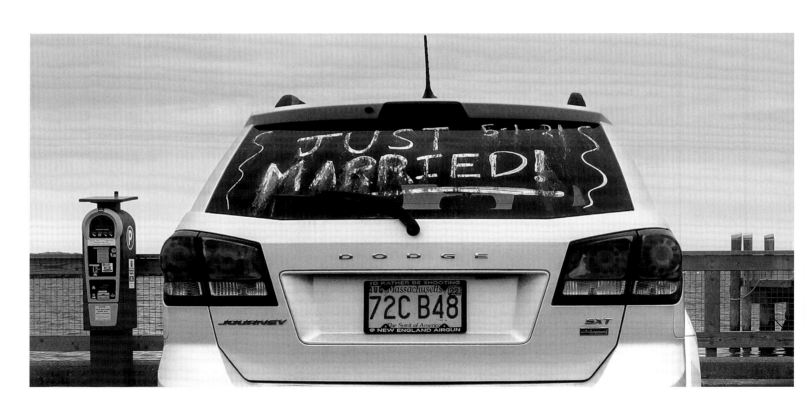

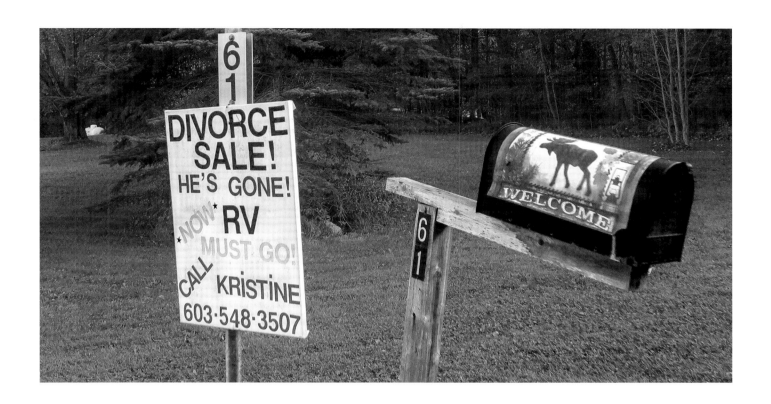

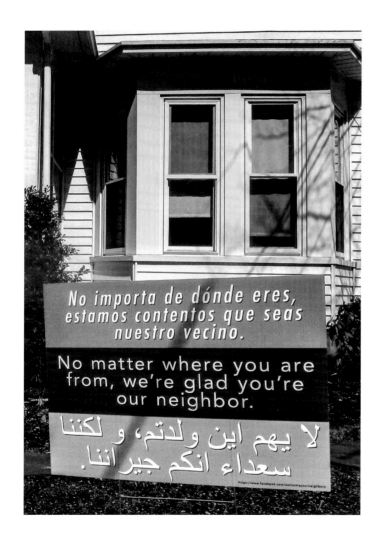

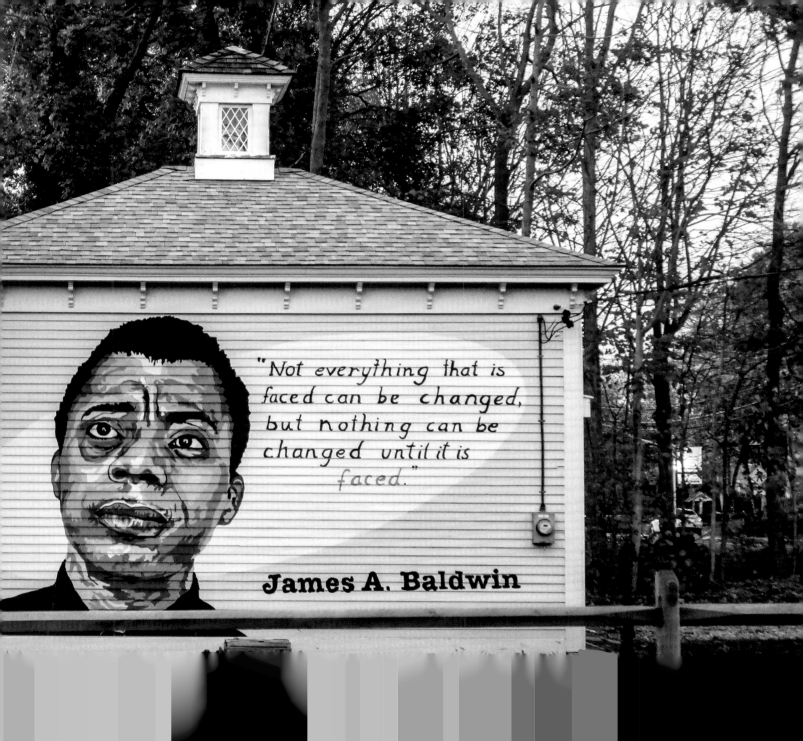

"Not everything that is faced can be changed, but nothing can be changed until it is faced."

James A. Baldwin

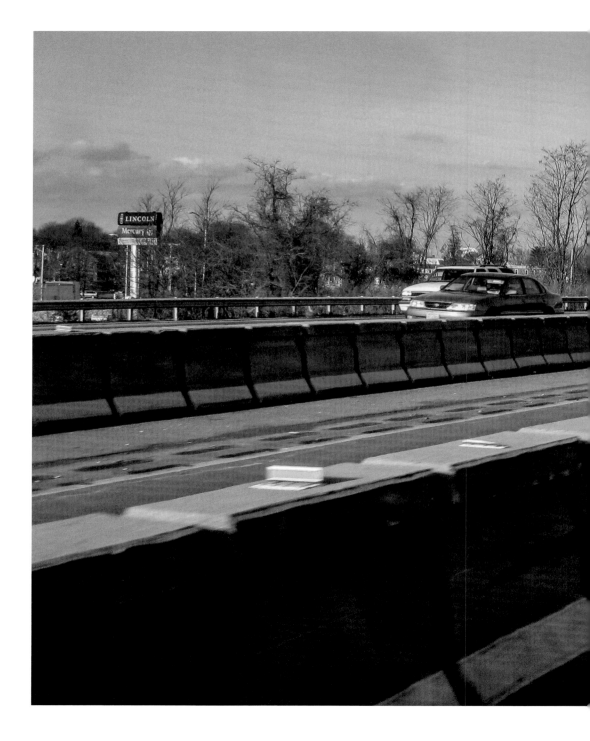

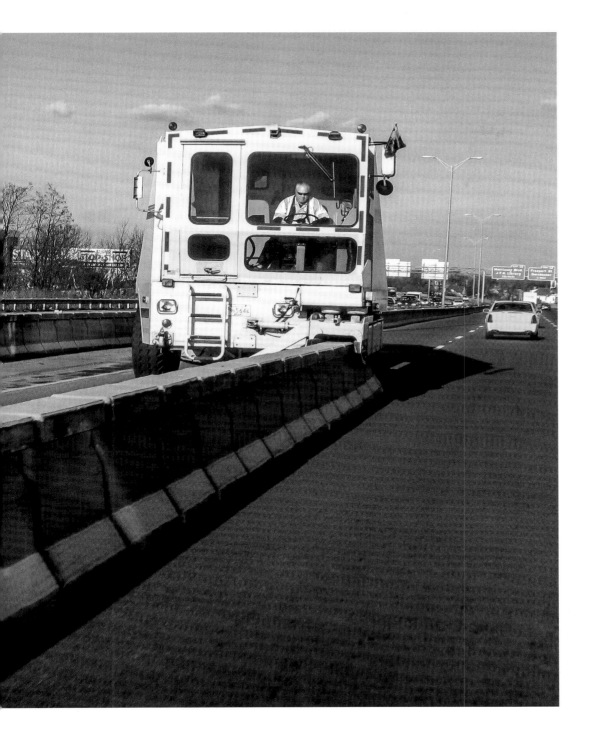

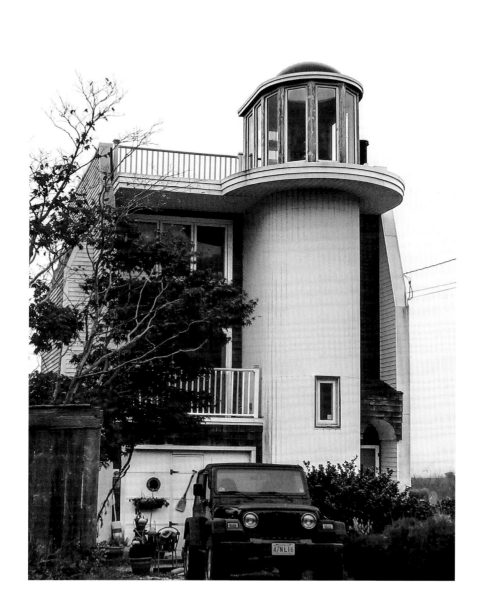

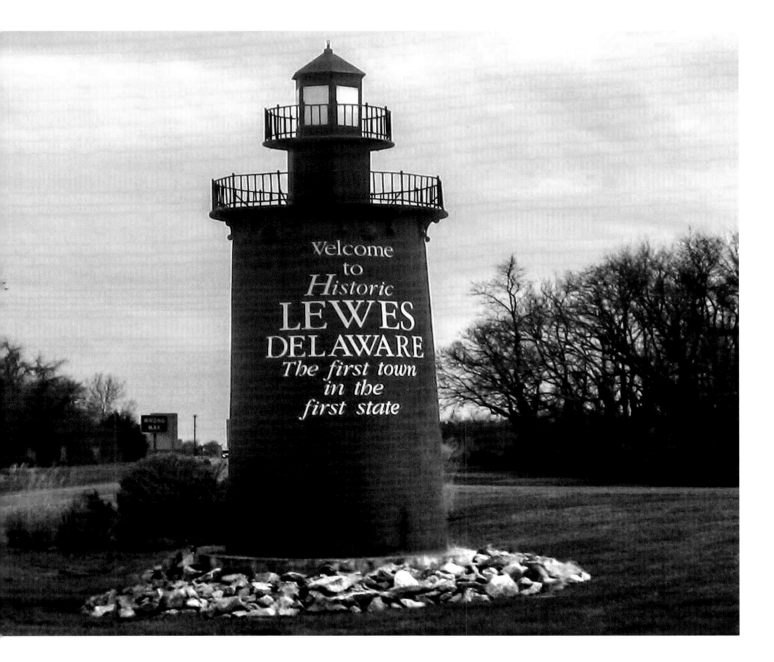

Welcome
to
Historic
**LEWES
DELAWARE**
*The first town
in the
first state*

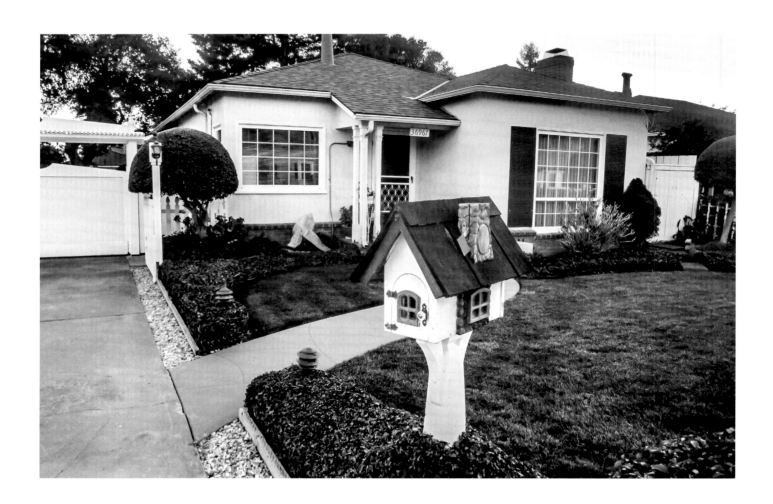

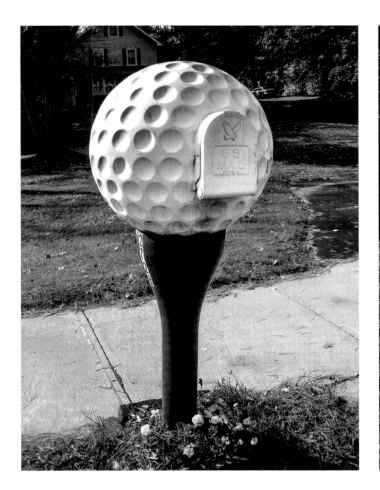

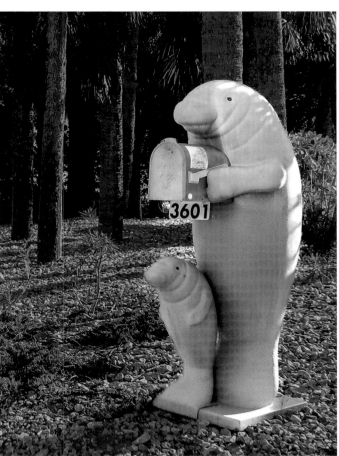

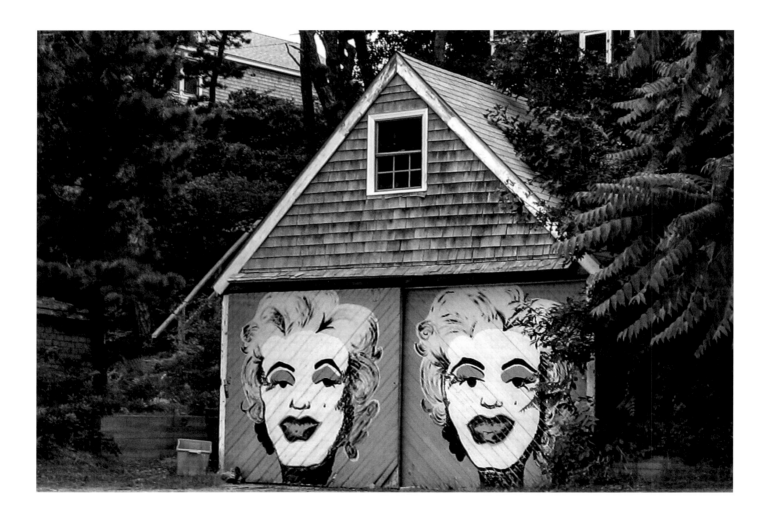

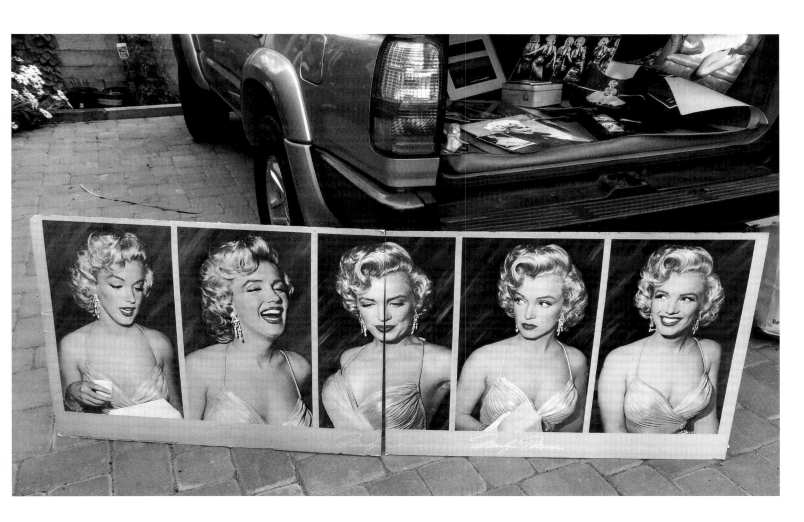

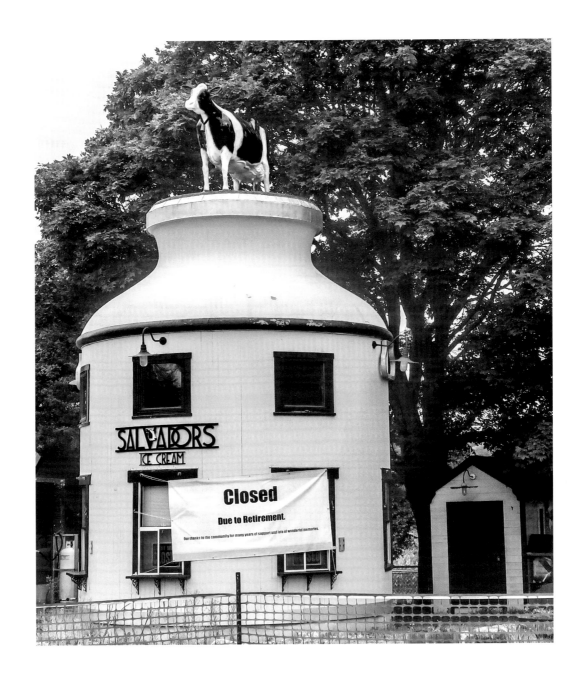

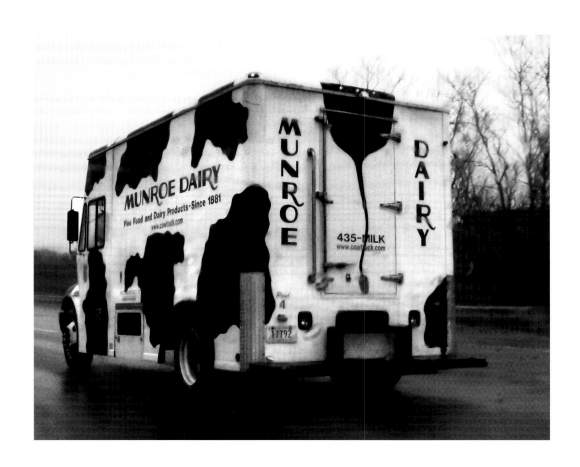

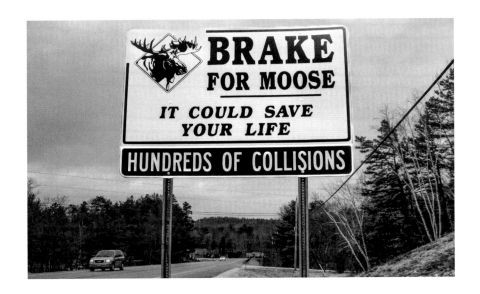

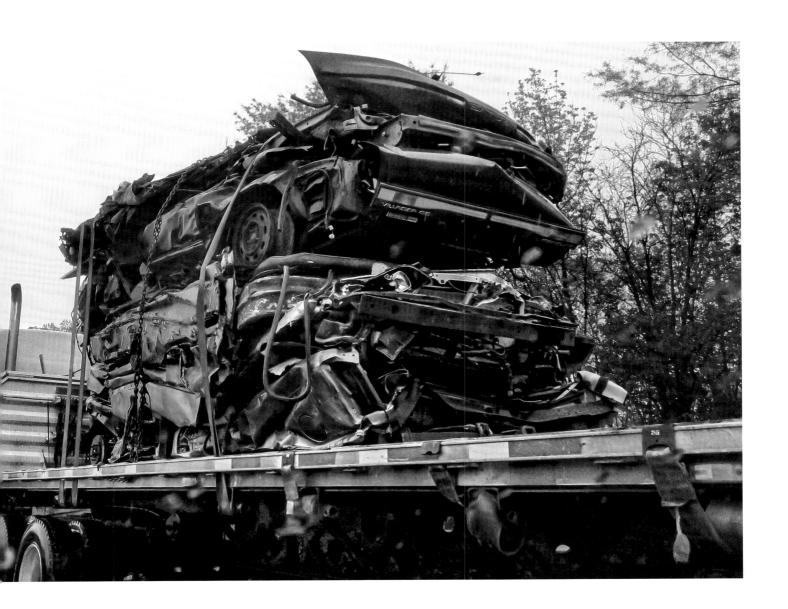

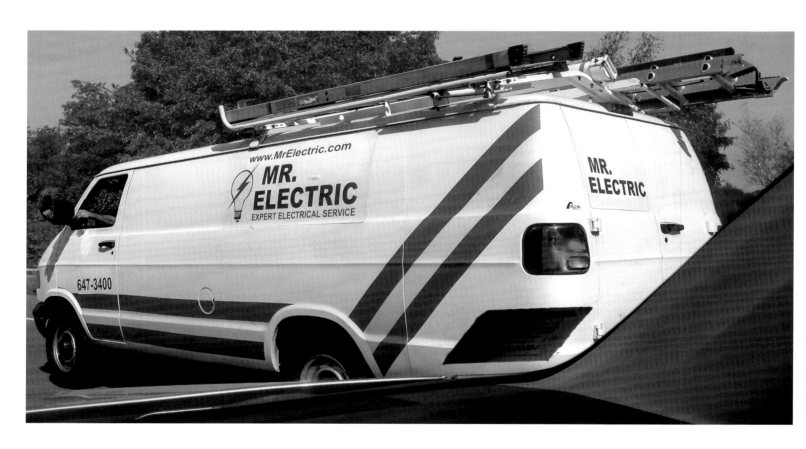

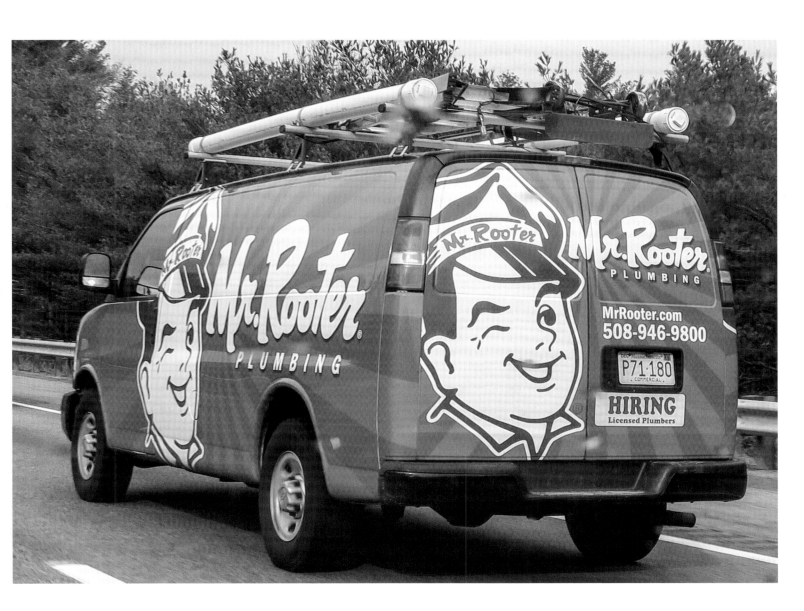

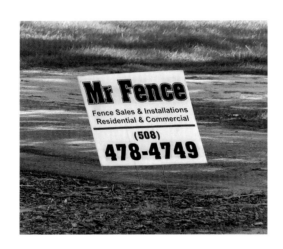

157

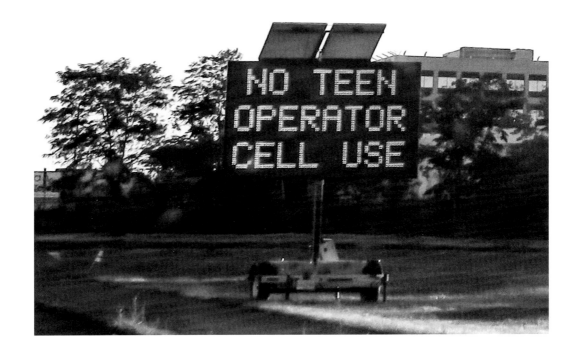

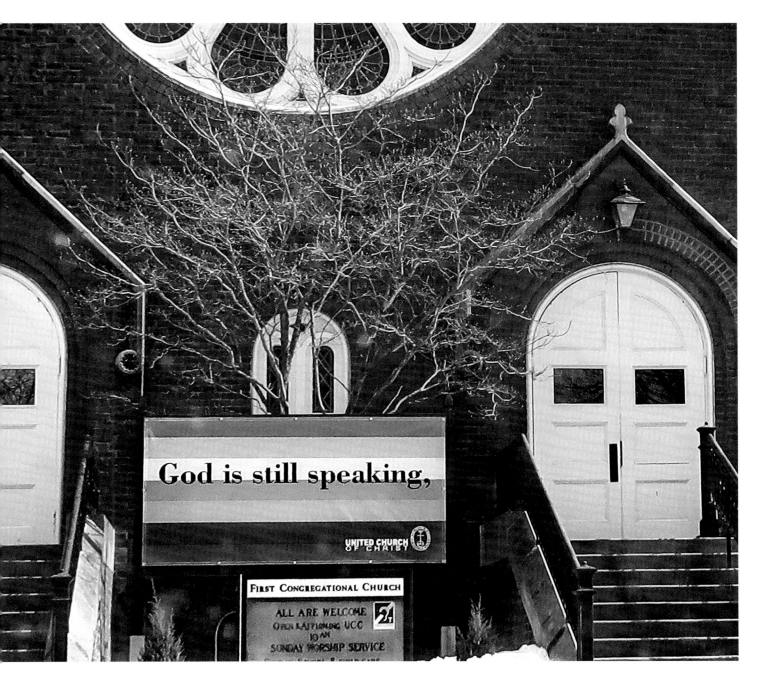

God is still speaking,

UNITED CHURCH OF CHRIST

First Congregational Church

ALL ARE WELCOME
OPEN & AFFIRMING UCC
10 AM
SUNDAY WORSHIP SERVICE

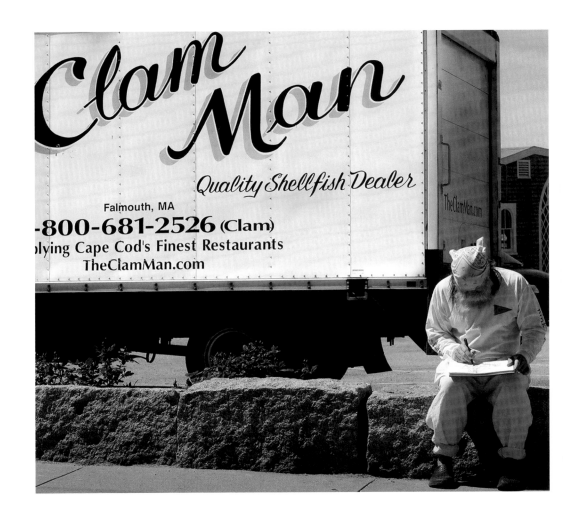

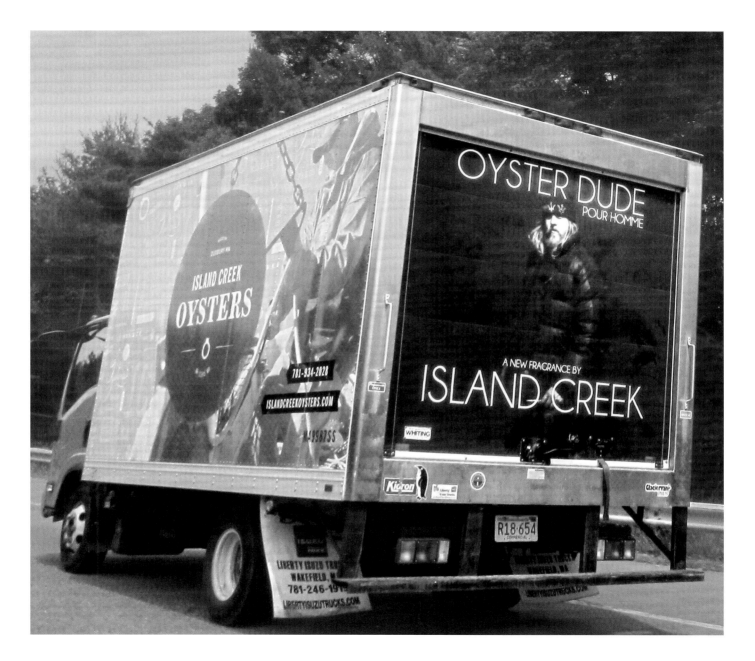

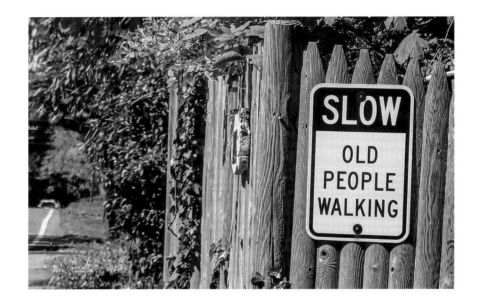

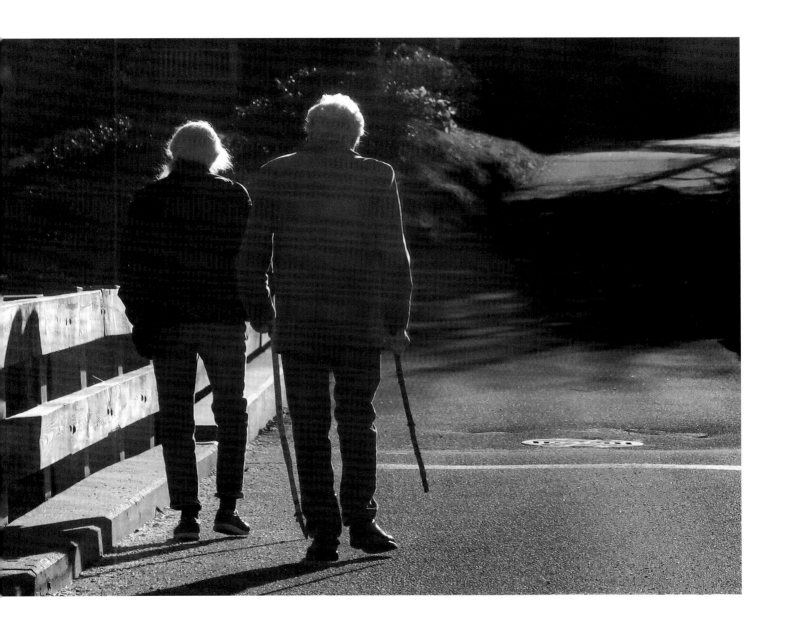

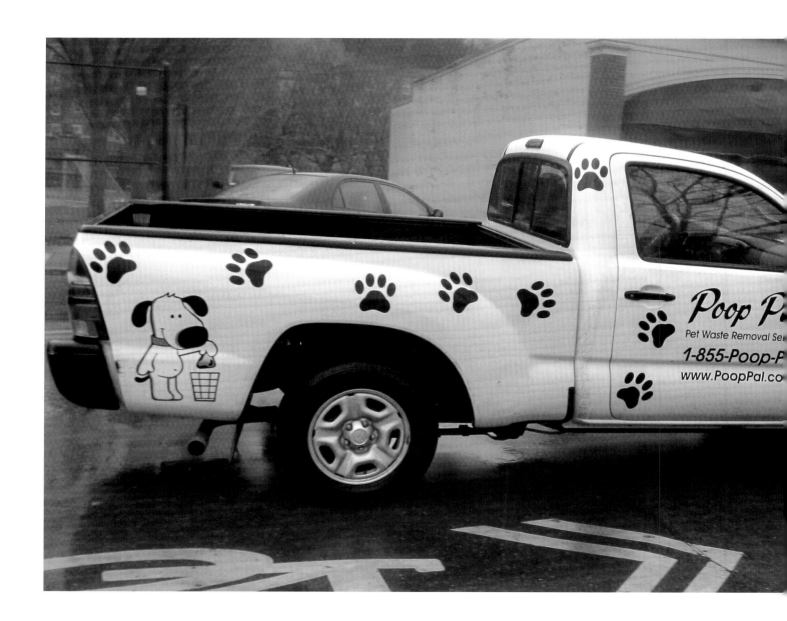

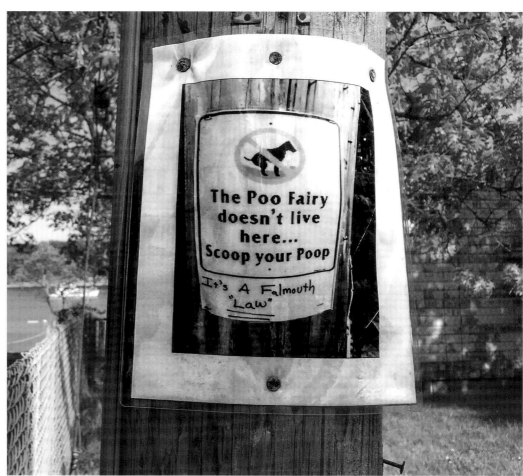

The Poo Fairy doesn't live here... Scoop your Poop

It's A Falmouth "Law"

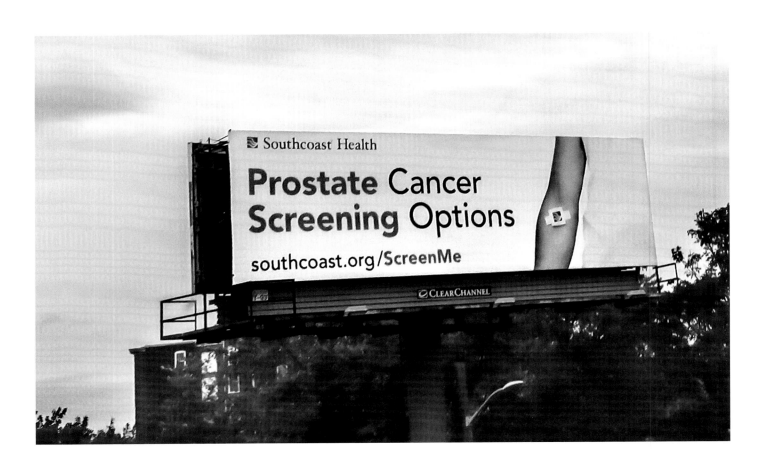

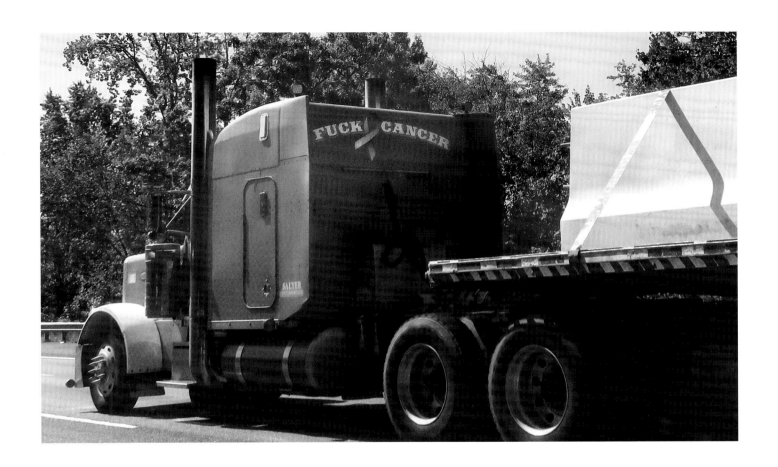

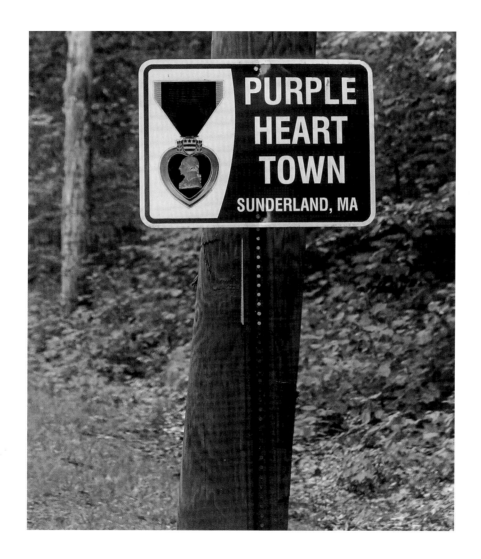

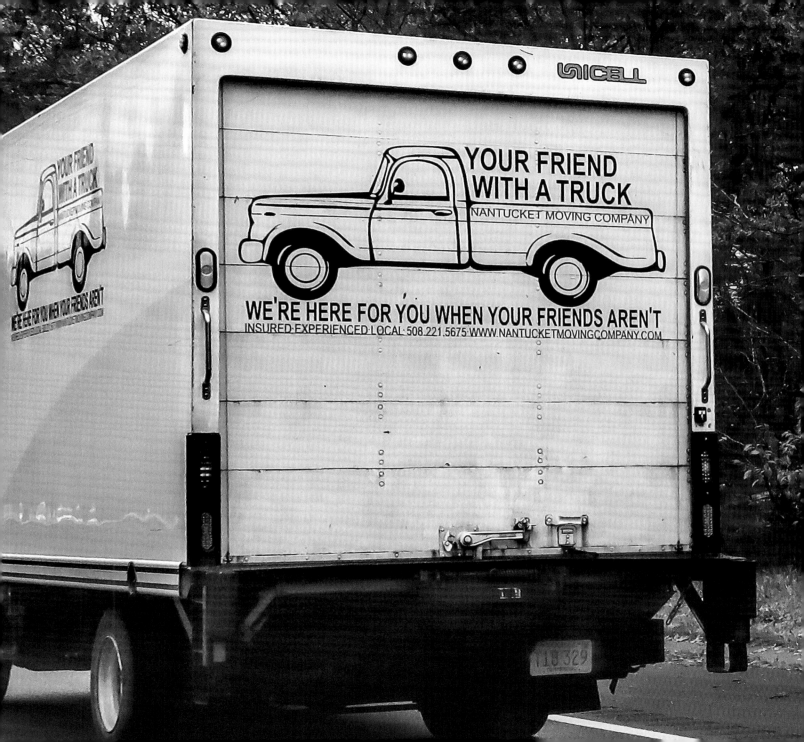

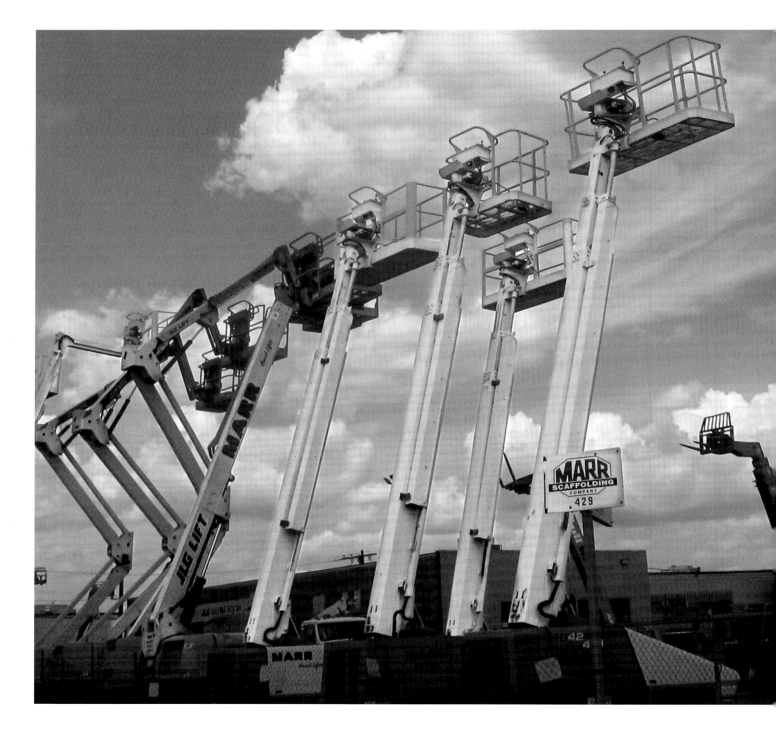

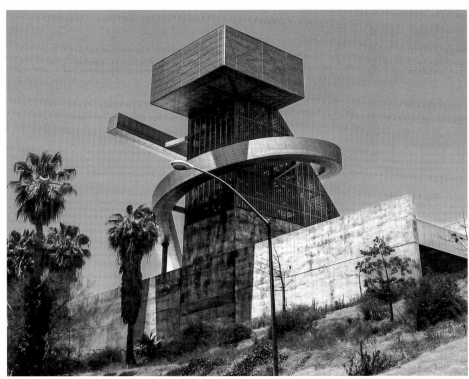

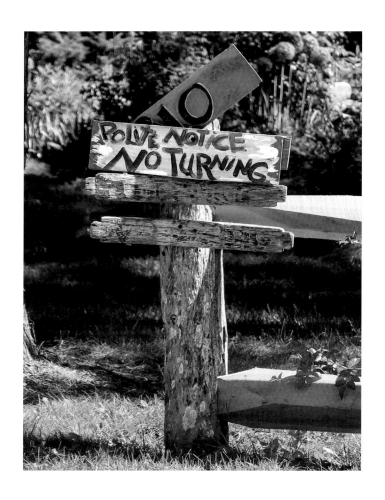

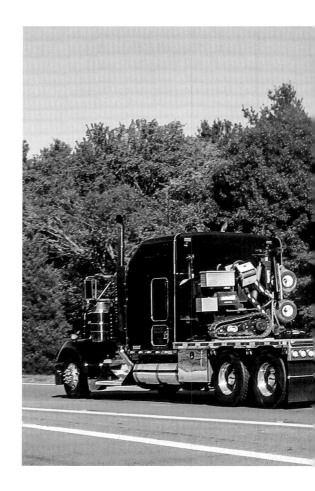

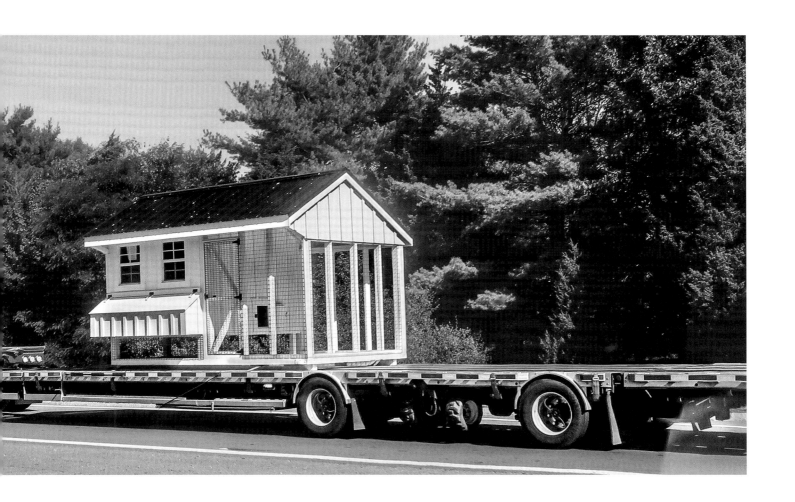

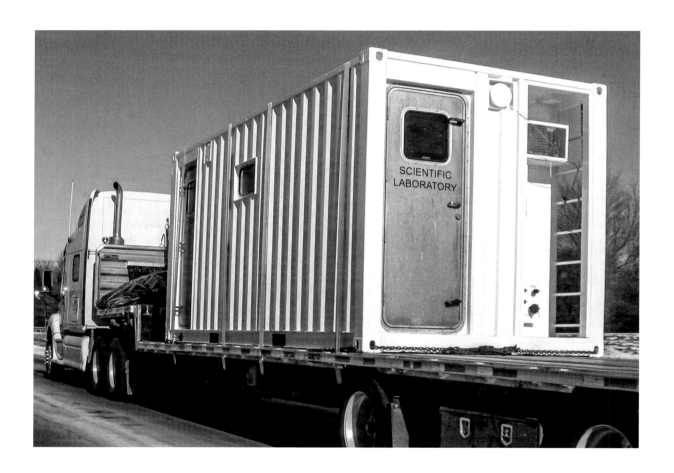

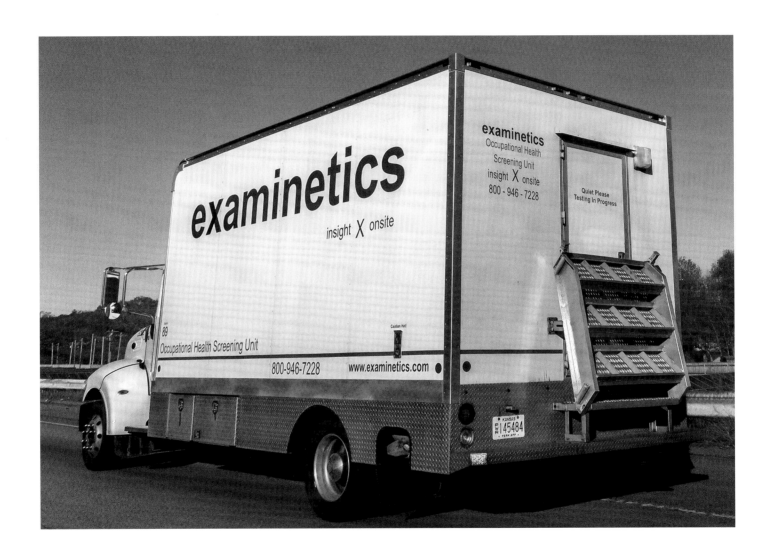

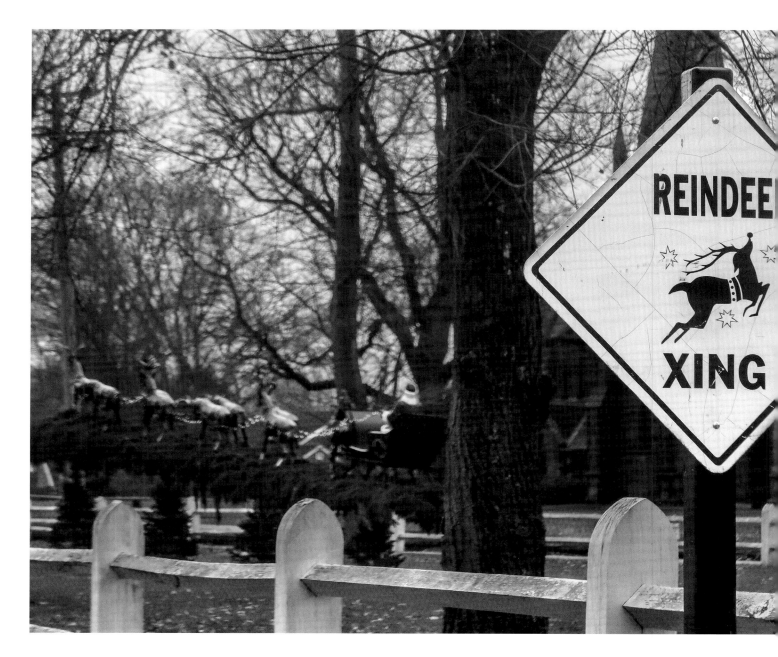

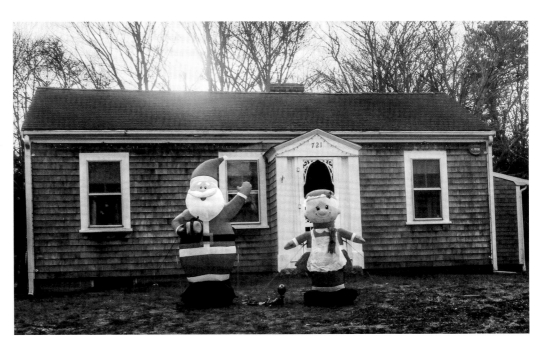

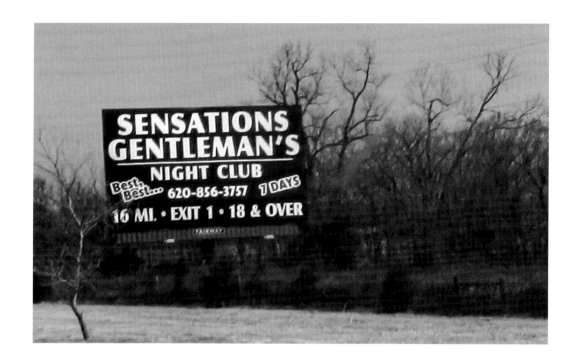

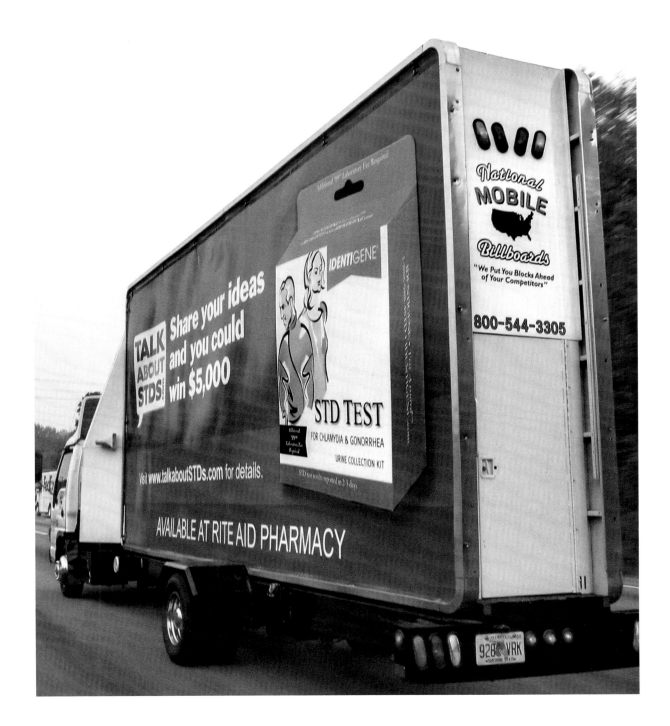

181

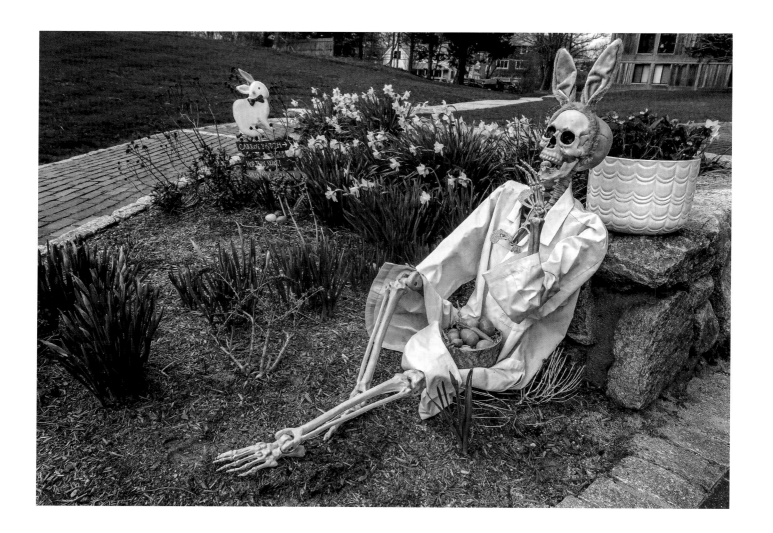

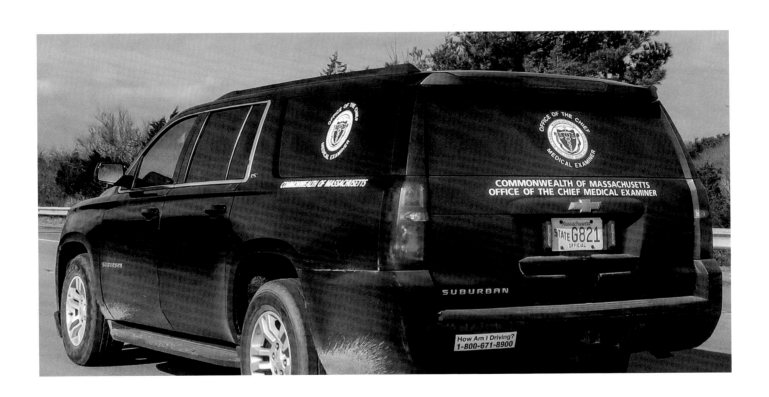

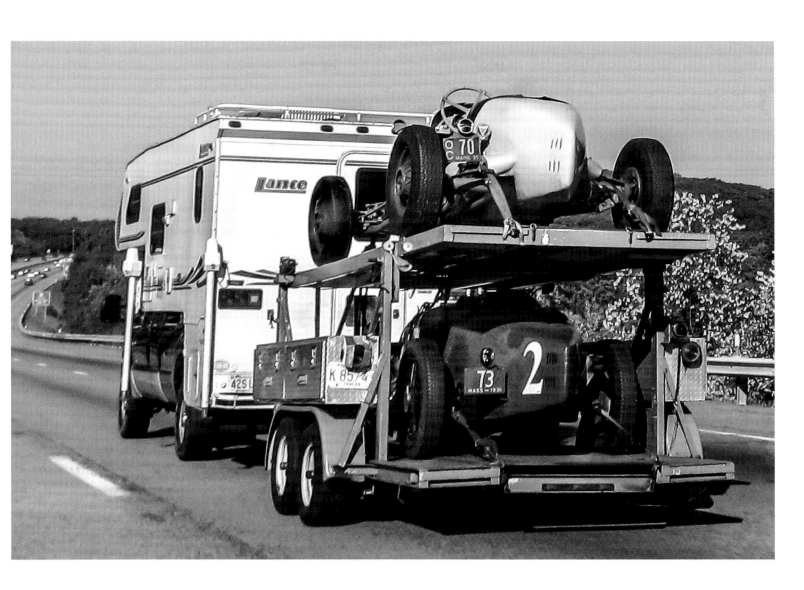

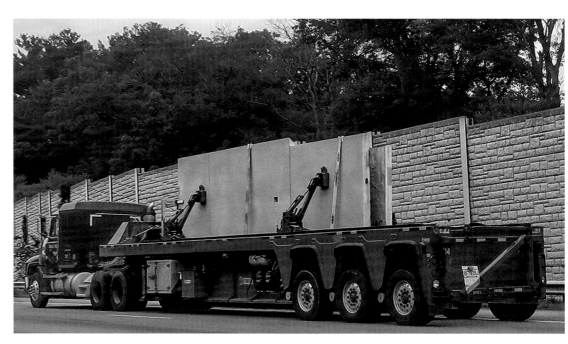

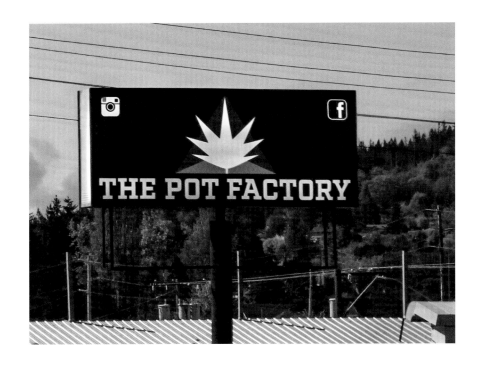

The
RECOVERY
ROOM
Custom Upholstery
& Slipcovers
Newark, Vt
802-467-8748

BDX 704

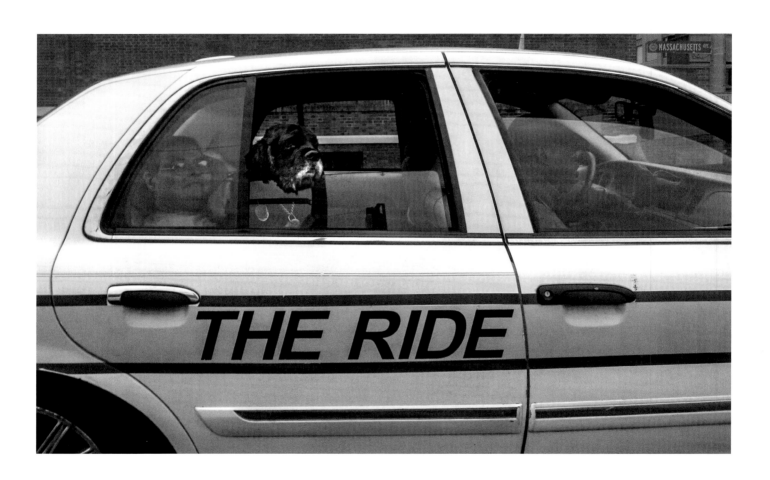

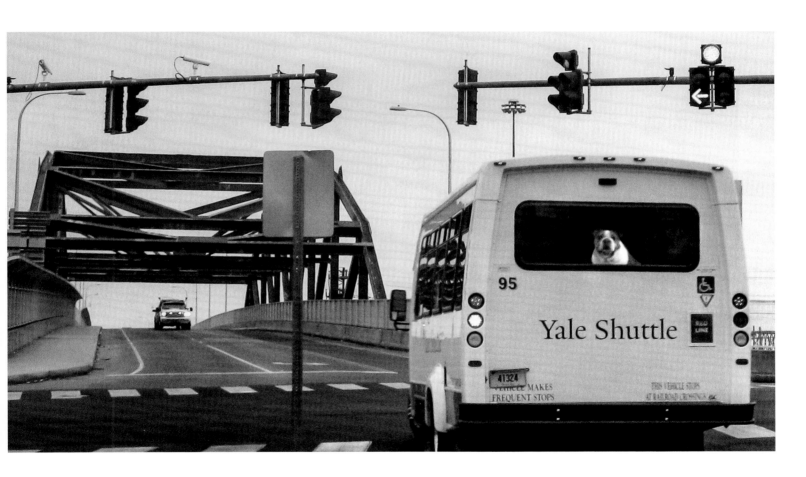

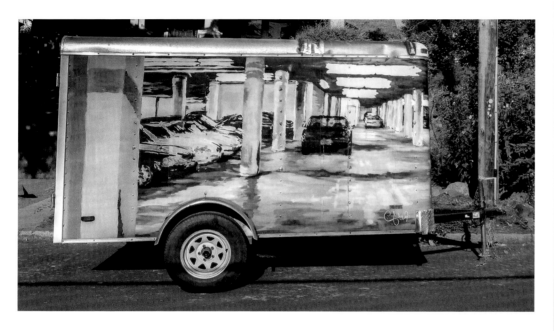

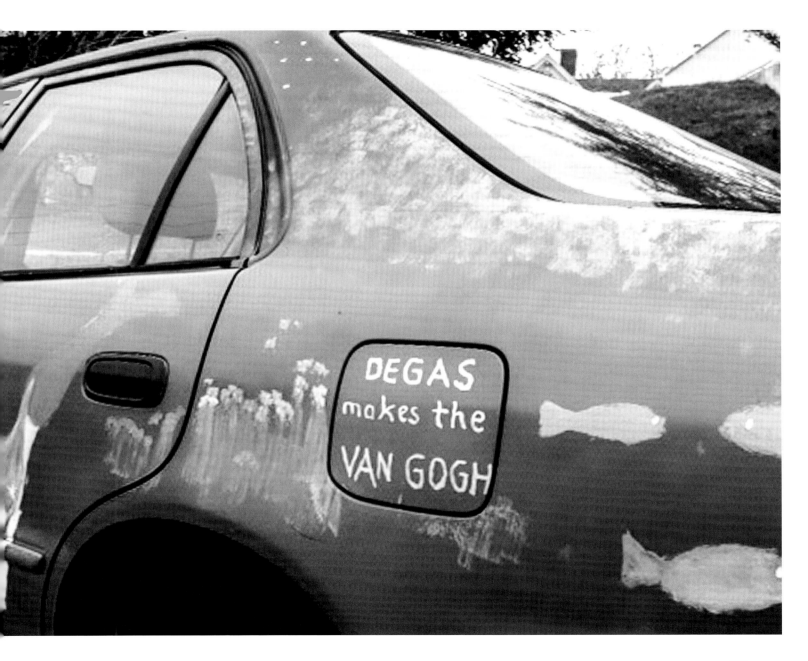

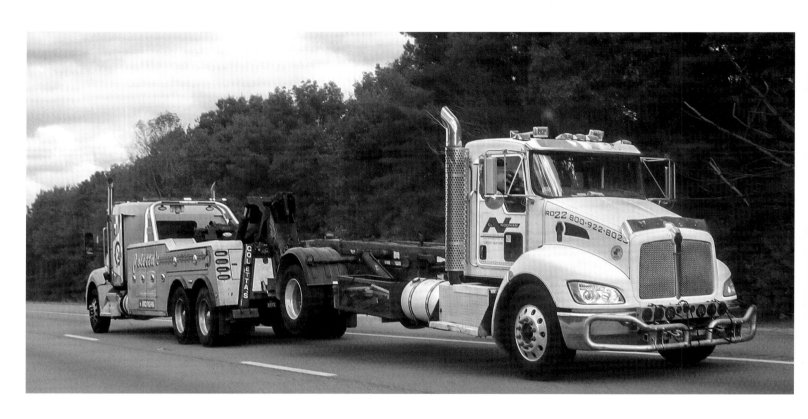

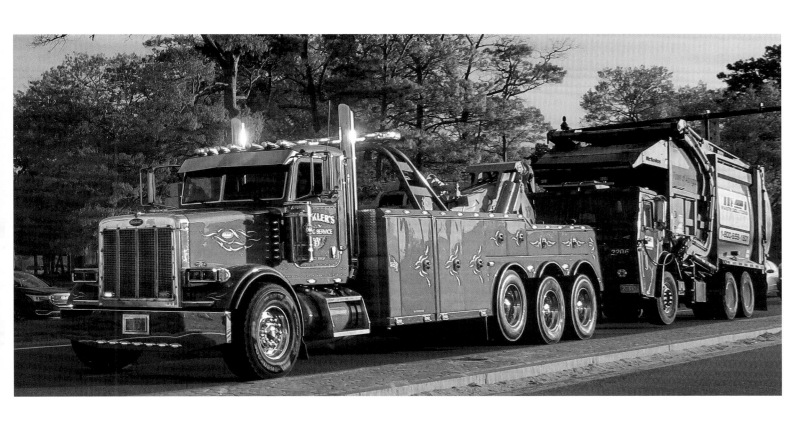

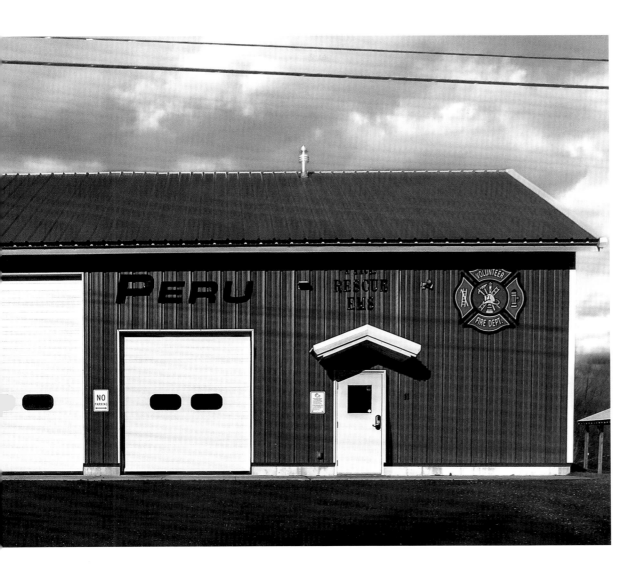

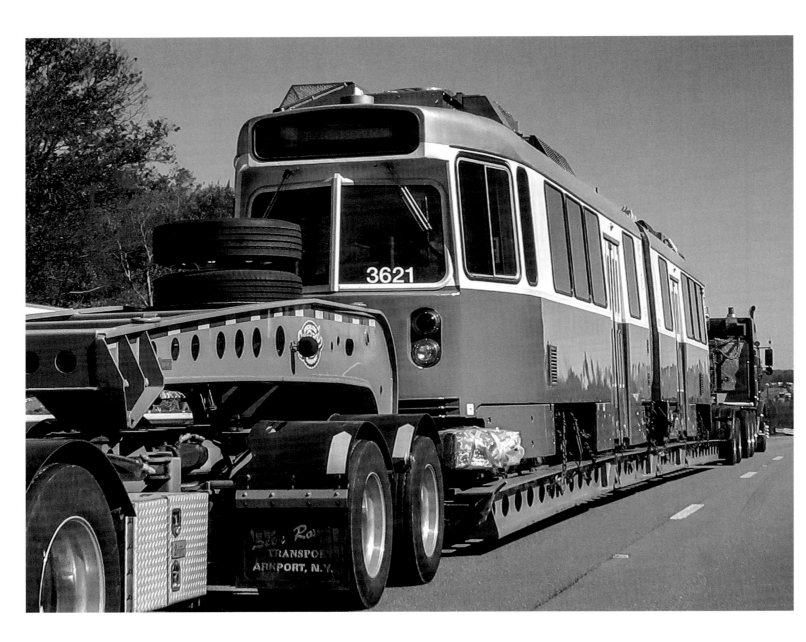

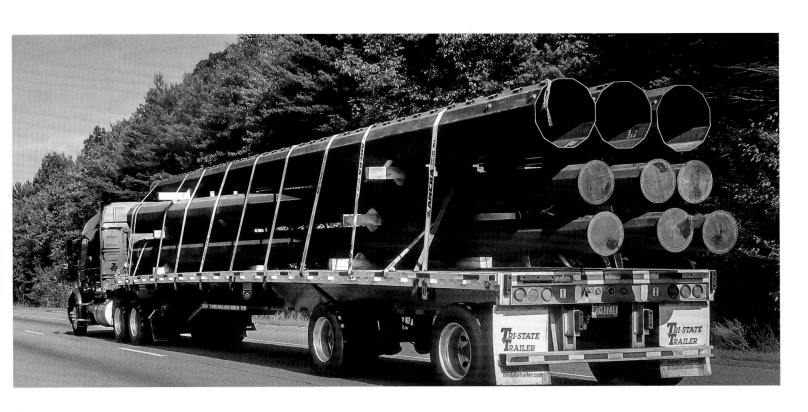

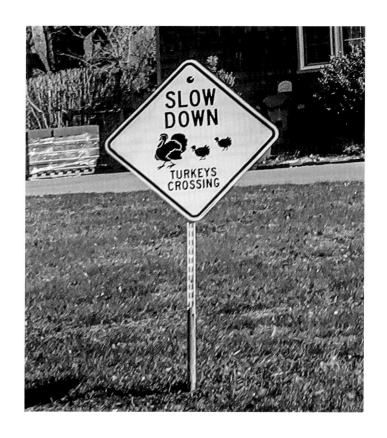

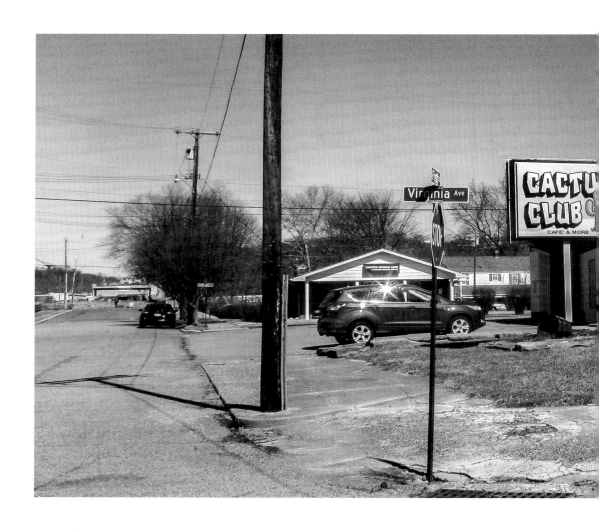

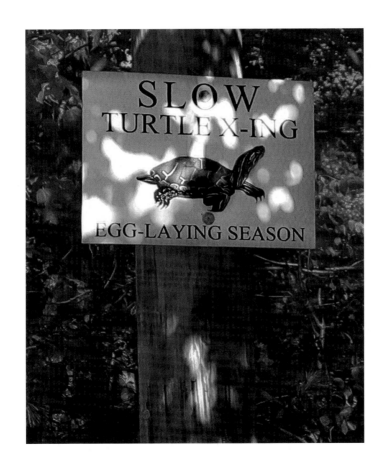

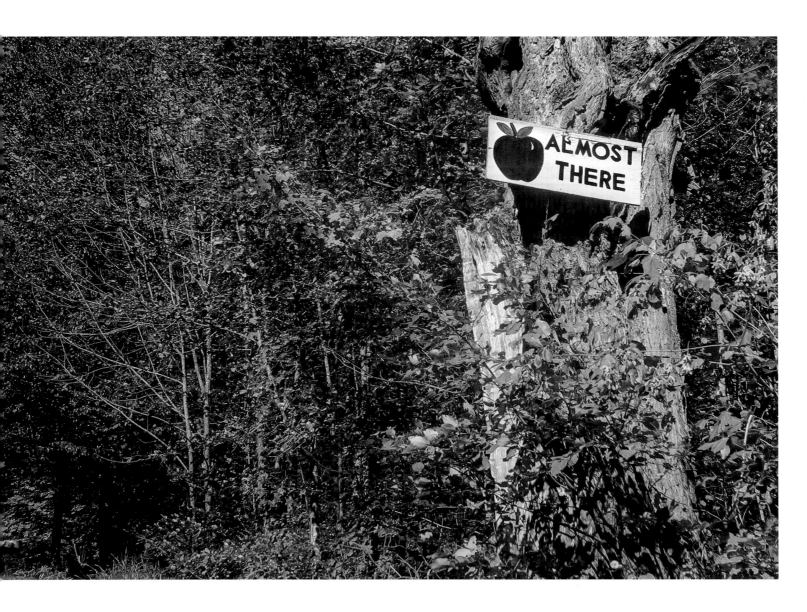

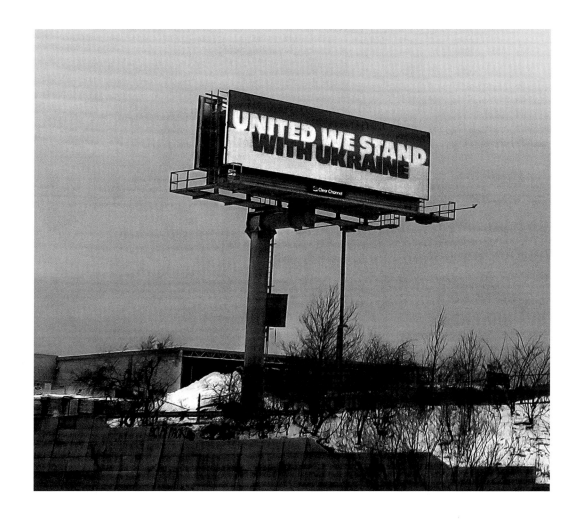

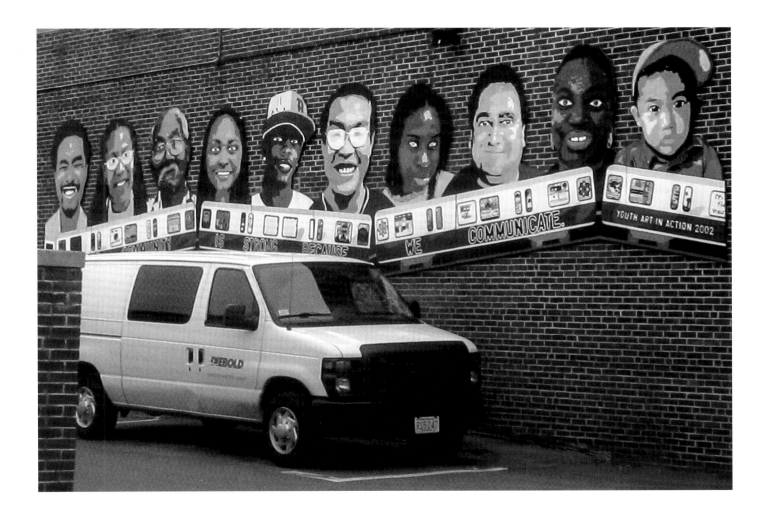

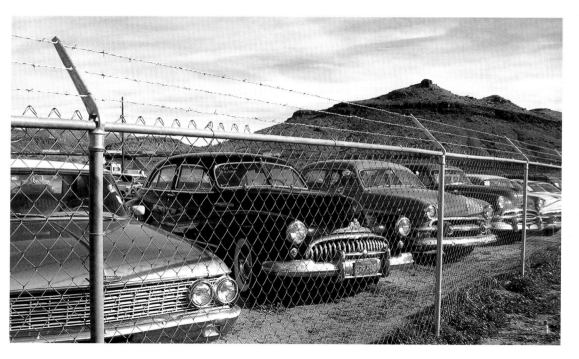

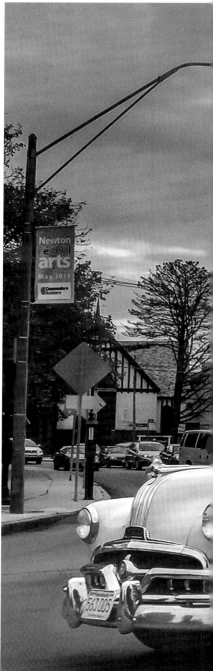

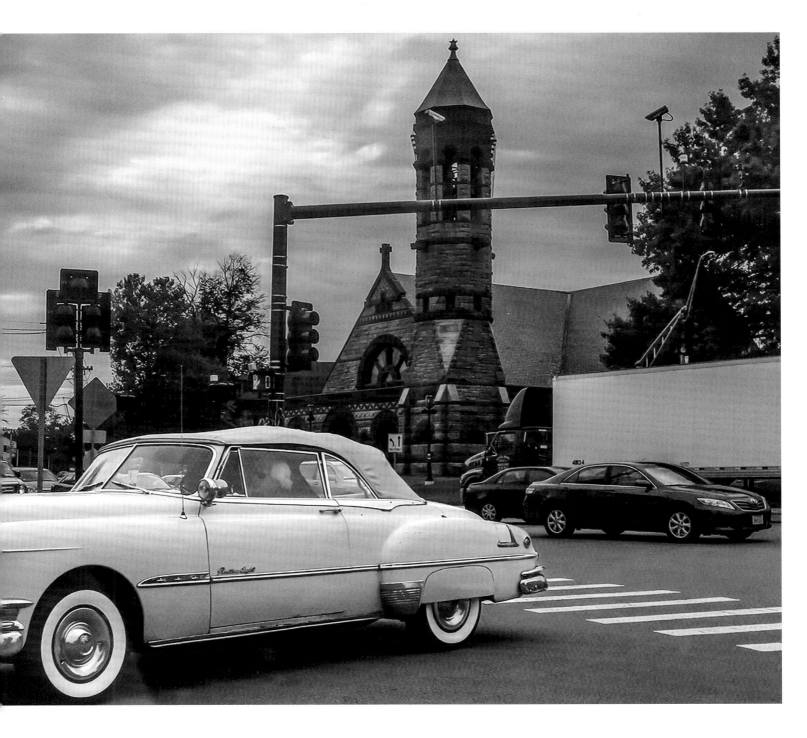

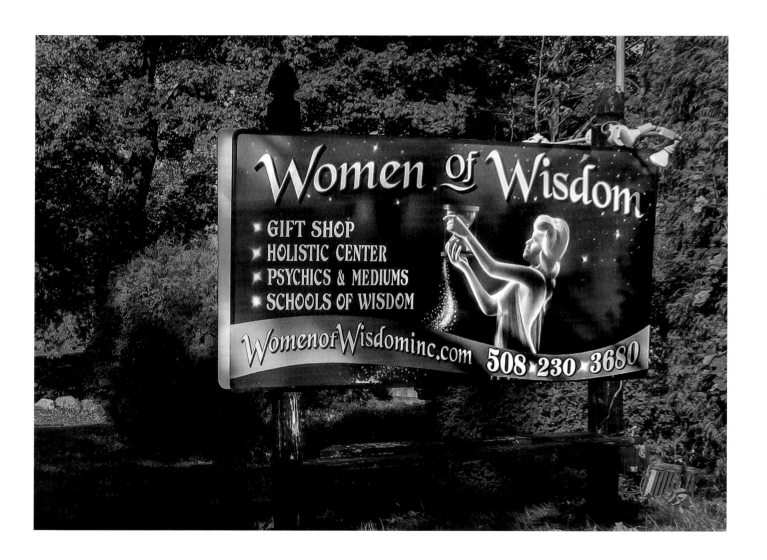

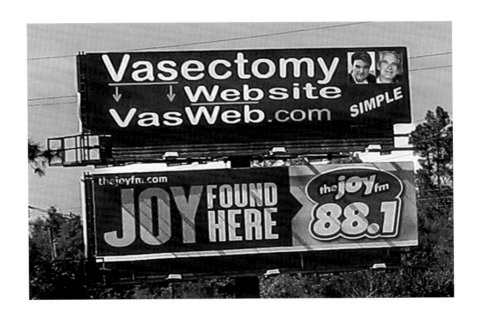

215

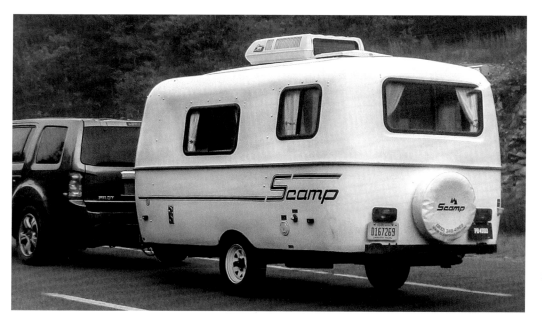

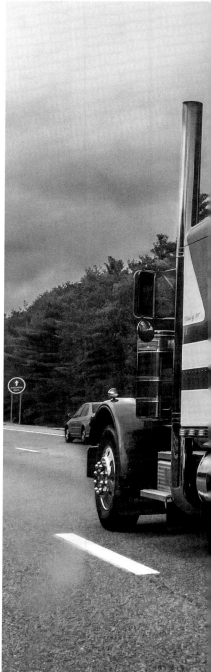

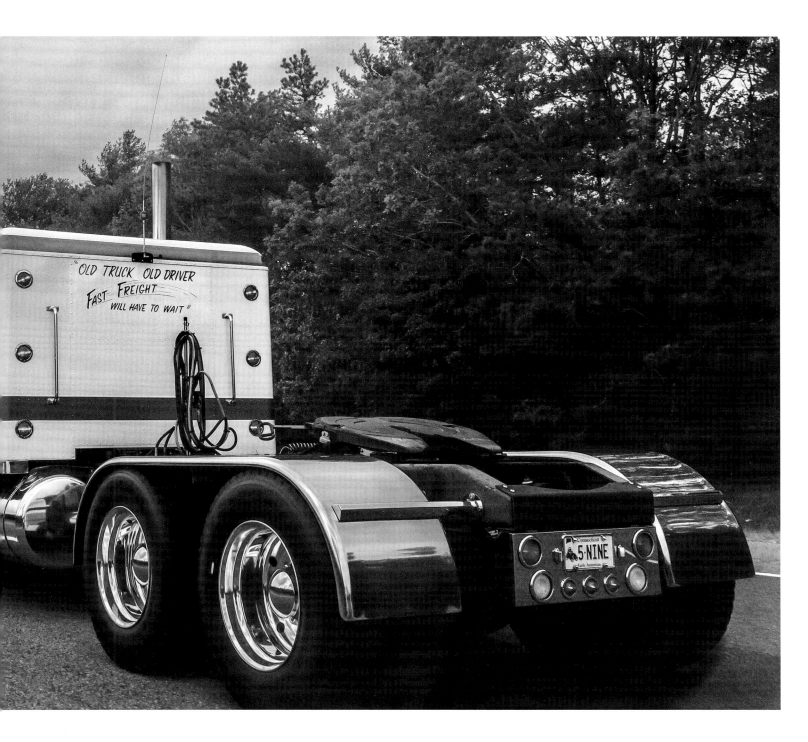

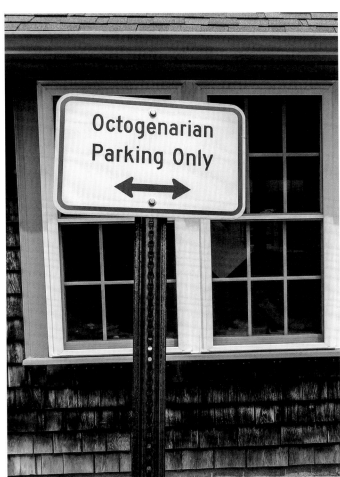

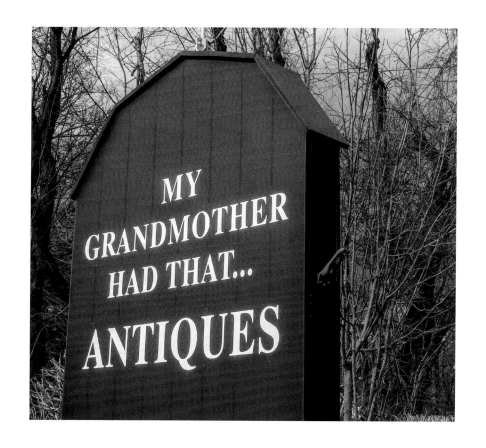

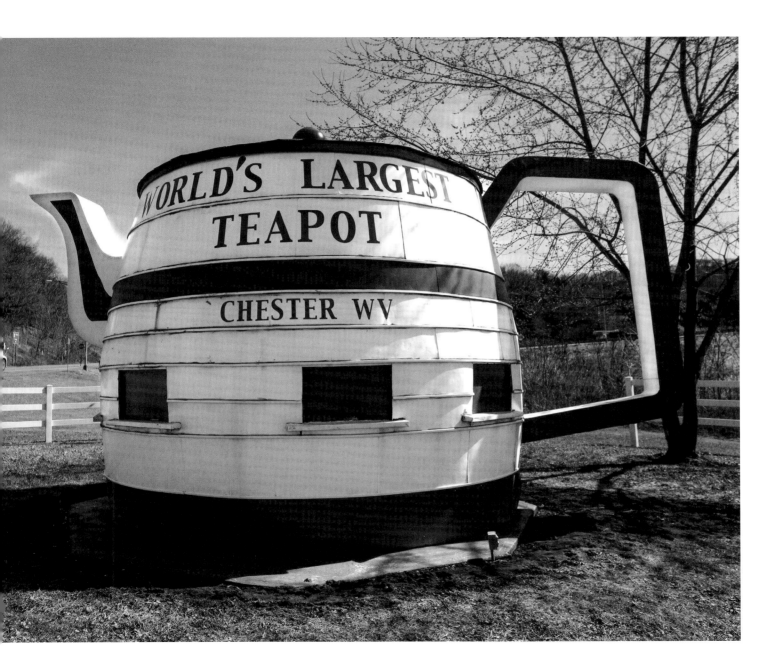

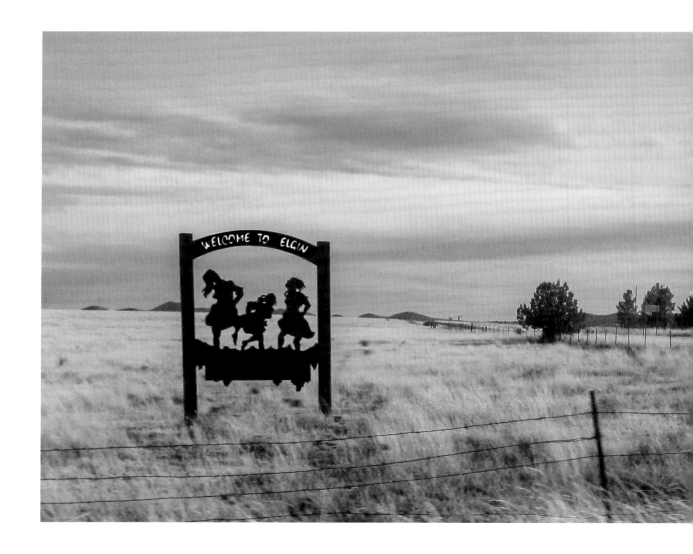

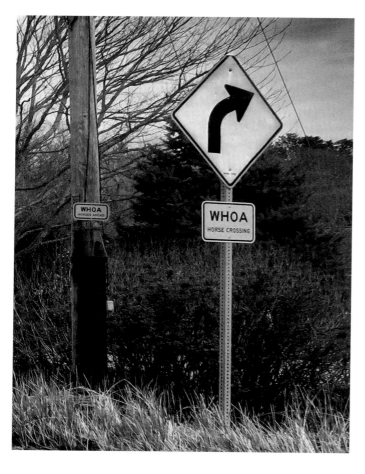

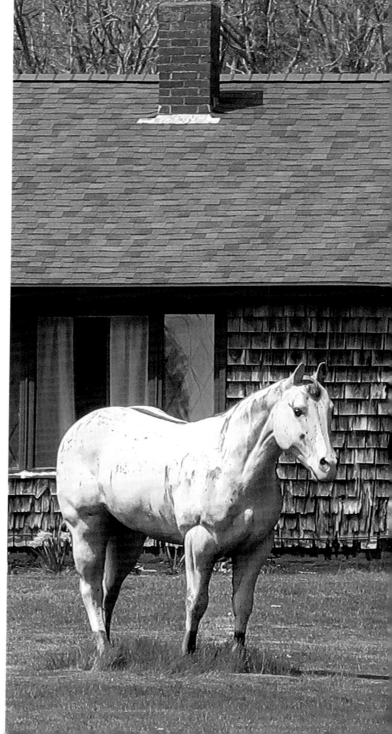

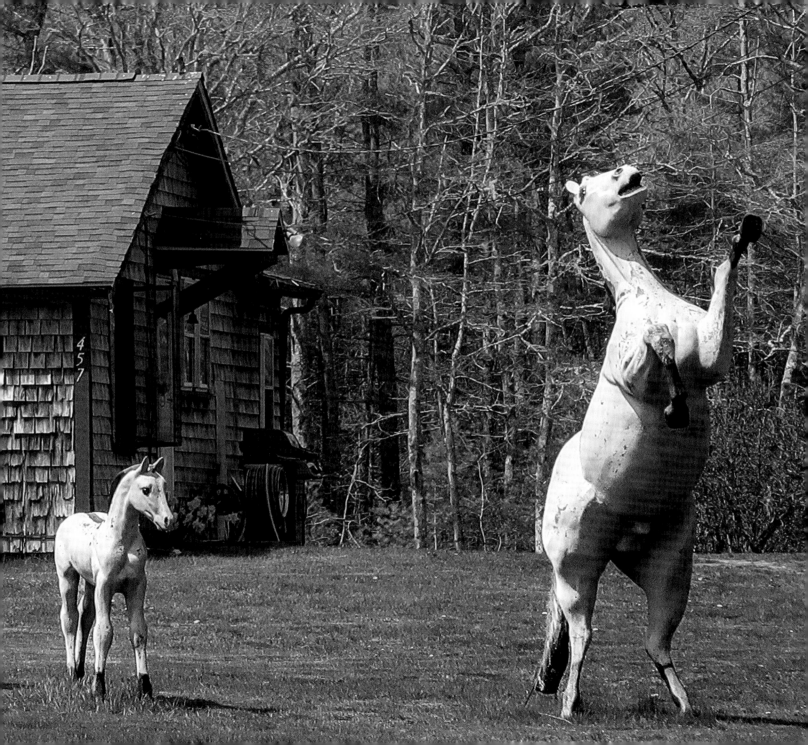

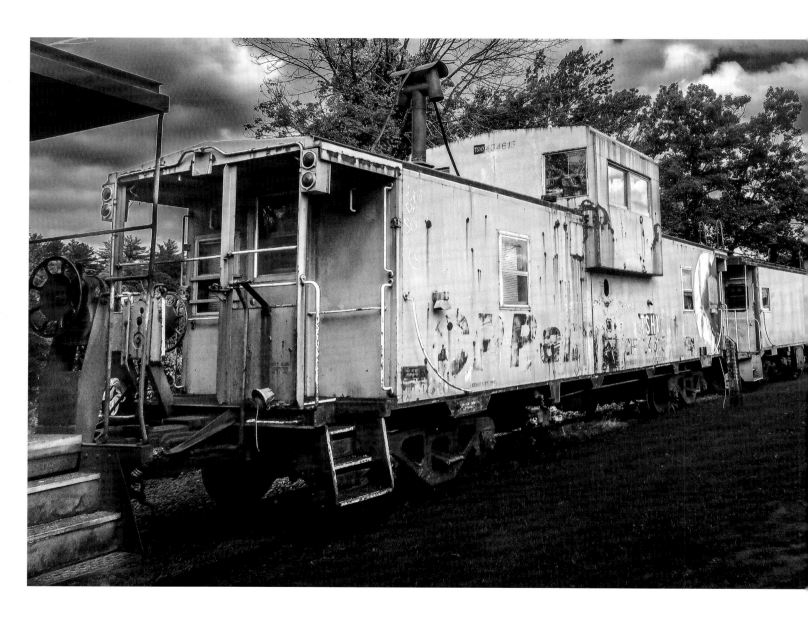

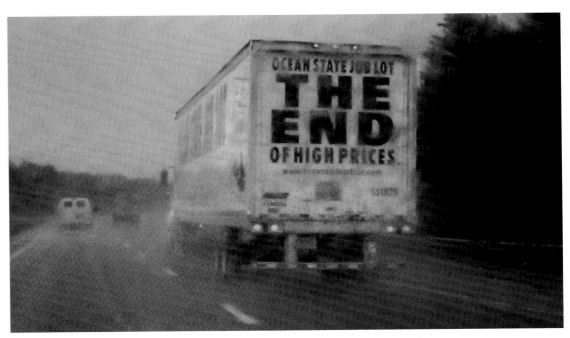

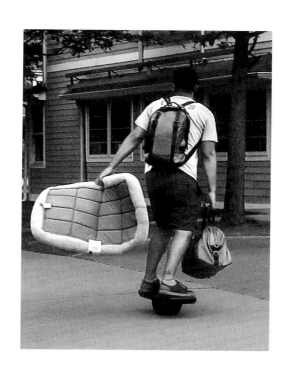